THE SKETCH IN COLOR

ROBERT S. OLIVER

 VAN NOSTRAND REINHOLD COMPANY
NEW YORK CINCINNATI TORONTO LONDON MELBOURNE

DEDICATED TO ALL OF MY STUDENTS, PAST AND PRESENT
AND
TO ALL OF MY ARTIST FRIENDS

LIBRARY OF CONGRESS CATALOG CARD NO. 83-1227
ISBN: 0-442-27205-7
ISBN: 0-442-27204-9 PBK

PRINTED IN HONG KONG

PUBLISHED BY VAN NOSTRAND REINHOLD COMPANY INC.
135 WEST 50TH STREET
NEW YORK, NEW YORK 10020

VAN NOSTRAND REINHOLD COMPANY LIMITED
MOLLY MILLARS LANE
WOKINGHAM, BERKSHIRE RG 11 2PY, ENGLAND

VAN NOSTRAND REINHOLD
480 LATROBE STREET
MELBOURNE, VICTORIA 3000 AUSTRALIA

MACMILLAN OF CANADA
DIVISION OF GAGE PUBLISHING LIMITED
164 COMMANDER BOULEVARD
AGINCOURT, ONTARIO M1S 3C7, CANADA

15 14 13 12 11 10 9 8 7 6 5 4 3 2 1

LIBRARY OF CONGRESS CATALOGING IN PUBLICATION DATA

OLIVER, ROBERT S., 1919—
 THE SKETCH IN COLOR
 INCLUDES INDEX
 1. COLOR DRAWING · TECHNIQUE. I TITLE

NC758 .O43 1983 741.2 83-1227
ISBN: 0-442-27205-7
ISBN: 0-442-27204-9 PBK

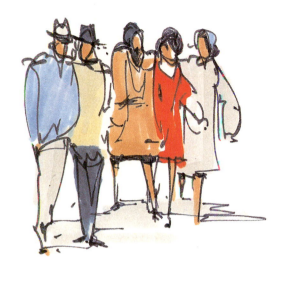

CONTENTS

1 INTRODUCTION 4

2 EQUIPMENT AND MATERIALS 6

3 SKETCHING POINTERS 16

 SKETCH CONSTRUCTION
 PERSPECTIVE
 TONES, TEXTURES
 SHADES AND SHADOWS
 COMPOSITION

4 TRANSPARENT WATERCOLOR OPAQUE WATERCOLOR 44

5 MARKERS 72

6 COLORED PENCILS - NON SOLUBLE COLORED PENCILS · SOLUBLE 90

7 MIXED MEDIA 112

8 SPECIAL SUBJECT SKETCHING AND COLORING 116

9 SKETCH PORTFOLIO 134

 BIBLIOGRAPHY 146

 INDEX 148

1 INTRODUCTION

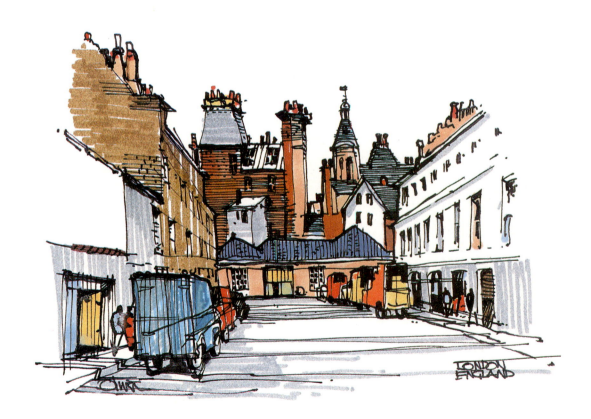

4

FOR MANY YEARS I HAVE EN-
JOYED SKETCHING. THIS ENJOY-
MENT WAS MAGNIFIED WITH
THE ADDITION OF FELT PENS,
FELT MARKERS AND COLORED
PENCILS. ADDING WATERCOLOR
TO ALL OF THESE INCREASED THE
ENJOYMENT AND INTRIGUE EVEN
FURTHER. IT IS THIS DISCOVERY
THAT I WISH TO SHARE IN THIS
BOOK. BY ILLUSTRATING THE
COMBINED USE OF MANY DIFFER-
ENT SKETCHING PENS WITH PEN-
CILS, MARKERS AND WATERCOLOR
MEDIUMS, IT IS HOPED THAT IT
WILL SUGGEST NEW DIRECTIONS.

NONE OF THESE SKETCHING TOOLS
AND MEDIUMS IS SO BULKY AND
INCONVENIENT THAT THEY CAN'T
BE CARRIED IN THE FIELD WITH
EASE. THE POSSIBILITIES IN
SKETCHING WILL BE EXPANDED
FURTHER BY ADDING AN ENLARGED
ASSORTMENT TO THE STUDIO
SUPPLY.

CERTAIN DRAWING FUNDAMENTALS
SUCH AS PERSPECTIVE, COMPOSIT-
ION, TONES, TEXTURES, SHADES
AND SHADOWS ARE PRESENTED
IN BRIEF FORM TO SERVE AS A
REVIEW OR REMINDER.

THE SKETCHES USED IN THIS BOOK
WERE DONE ON LOCATION FOR THE
MOST PART WITH COLOR USUALLY
ADDED ON THE SPOT. ALL OF
THE REPRODUCTIONS ARE ACTUAL
SIZE.

FINALLY, IT IS HOPED THAT THIS
BOOK WILL OPEN A DOOR TO
SKETCHING THAT HAS BEEN UN-
LOCKED BY THE ADVENT OF SO
MANY NEW PRODUCTS IN THE
GRAPHIC ARTS FIELD.

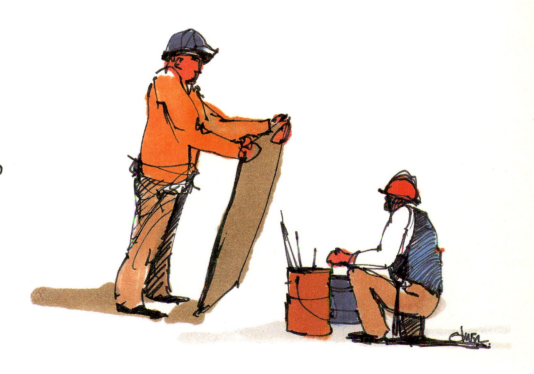

2 MATERIALS AND EQUIPEMENT

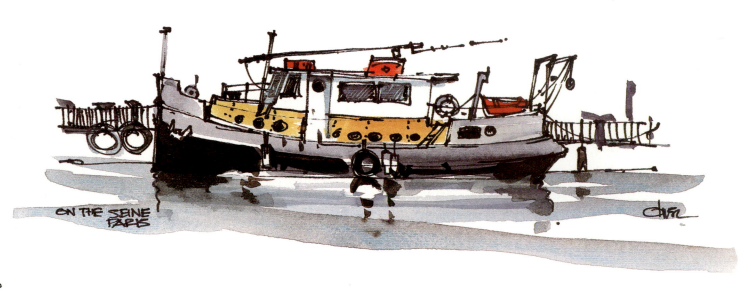

ON THE SEINE
PARIS

6

THERE ARE A WIDE VARIETY OF MATERIALS USED FOR SKETCHING. EACH INDIVIDUAL WILL NARROW THE QUANTITY AS THEIR PERSONAL PREFERENCE DICTATES. ANOTHER LIMITING FACTOR WILL BE THE QUANTITY THAT CAN BE TAKEN INTO THE FIELD. THE LIST THAT FOLLOWS COVERS AN ADEQUATE AND EFFECTIVE VARIETY OF SKETCHING EQUIPMENT WITHOUT IT BEING BURDONSOME.

1. PENS

2. PENCILS

3. PENCIL SHARPENER AND SANDPAPER PAD

4. MARKERS

5. WATERCOLORS

6. SKETCH BOOKS

7. RADIO, CAMERA AND BINOCULARS

8. CARRYING CASE

PENS

PENS THAT CARRY THEIR OWN INK SUPPLY ARE VERY CONVENIENT TO USE AND CARRY AROUND. THESE PENS HAVE METAL POINTS RANGING FROM A SOFT, PLIABLE SKETCH PEN THROUGH THE RIGID TIP OF A FOUNTAIN PEN TO THE UNYIELDING POINT OF A TECHNICAL DRAFTING AND BALL POINT PEN.

OTHER PENS IN THE SELF-CONTAINED INK SUPPLY CATEGORY ARE THE VERY POPULAR AND VERSATILE FELT AND FIBER TIP PENS. THESE ARE INEXPENSIVE. SOME INKS USED IN THE PENS ARE PERMANENT AND COLORED, BUT IN SOME CASES THE INKS ARE WATER SOLUBLE AND CAN BLEED WHEN USING WATERCOLOR PAINTS.

OF THE PENS THAT MUST BE DIPPED IN AN OUTSIDE INK SUPPLY, THE MOST POPULAR ARE THOSE OF THE QUILL TYPE POINT AND SPEEDBALL POINT. BOTH POINT TYPES COME IN A VARIETY OF SIZES. THE INK SUPPLY IS AVAILABLE IN BLACK AND COLORS.

PENCILS

THE BEST BLACK PENCILS FOR SKETCHING ARE THOSE CONTAINING GRAPHITE LEADS. THESE ARE PREFERRED OVER CARBON LEADS BECAUSE THEY SMUDGE THE LEAST AND NEED NO FIXATIVE. THEY ARE AVAILABLE FROM VERY HARD TO VERY SOFT. THERE ARE MECHANICAL DRAFTING PENCILS THAT HAVE REMOVABLE LEADS THAT CAN GREATLY REDUCE THE BULK OF CARRYING TOO MANY PENCILS IN THE FIELD. THE LEADS ARE VERY EASY TO KEEP POINTED WITH A SANDPAPER PAD. THEY COME IN MANY GRADES AND COLORS. FINALLY, THE BLACK PENCIL IN A COLORED PENCIL SET PROVIDES A DIFFERENT TEXTURE AND OFTEN A BLACKER BLACK THAN THAT ACHIEVED WITH GRAPHITE LEADS.

THERE ARE A NUMBER OF COLORED PENCIL MAKES FOR SKETCHING THAT ARE DISTINGUISHED BY THE TEXTURE OF THEIR LEADS AND THE WATER SOLUBLE FEATURE OF SOME MAKES.

MARKERS

MARKERS HAVE A SELF-CONTAINED INK SUPPLY AND ARE EQUIPPED WITH SEVERAL POINT SIZES AND SHAPES. THE PENS COME IN A LARGE ASSORTMENT OF COLORS, GREYS, AND BLACK. THOSE TAKEN INTO THE FIELD SHOULD BE WELL CHOSEN AND FEW IN NUMBER. TOO MANY TOOLS CAN BE VERY CUMBERSOME.

WATERCOLORS

ONE OF THE MOST SUCCESSFUL TRANSPARENT WATERCOLOR KITS FOR SKETCHING IS A SMALL TWELVE PAN PLASTIC SET WITH A SMALL QUALITY BRUSH MARKETTED BY WINSOR AND NEWTON COMPANY. IF THE COLORS PROVIDED WITH THE KIT ARE NOT TO YOUR LIKING, THEY CAN BE REPLACED BY TUBE COLORS OF YOUR OWN CHOICE.

OPAQUE COLORS ARE USUALLY IN TUBES AND SHOULD BE SQUEEZED OUT AS NEEDED ON A SMALL PLASTIC PALLETTE AT THE TIME THAT THEY ARE USED.

A SMALL PLASTIC BOTTLE OF WATER IS ESSENTIAL WITH BOTH MEDIUMS.

SKETCH BOOKS

A GOOD QUALITY PAPER SHOULD BE USED FOR SKETCHING. THERE ARE MANY OF THESE ON THE MARKET, BOUND IN A VARIETY OF SIZES AND PROVIDING MANY SURFACES. PAPERS MAY VARY FROM A HARD SURFACE OF BRISTOL BOARD TO A VERY ABSORBANT SURFACE OF SUMI PAPER. EACH WILL PROVIDE A DIFFERENT EXPERIENCE AND EFFECT WHEN USED WITH EACH SKETCHING TOOL. PORTABILITY FOR FIELD SKETCHING IS IMPORTANT SO KEEP THE SIZE AND QUANTITY REASONABLE. MOST PAPERS CAN BE USED WITH MARKERS AND WATERCOLORS. SOME ARE ESPECIALLY FABRICATED FOR USE WITH EACH MEDIUM.

RADIO, CAMERA AND BINOCULAR

THESE ARE NOT ESSENTIAL BUT CAN BE USEFUL AT TIMES. THE CAMERA IS HANDY FOR BRINGING BACK SUBJECT MATTER FOR USE IN LATER DRAWINGS OR SKETCHES. THE BINOCULAR ALLOWS EXAMINATION OF DETAIL WITHOUT HAVING TO GET UP AND MOVE IN CLOSER. THE RADIO IS FOR FUN.

CARRYING CASE

THIS CAN TAKE ANY FORM AS LONG AS IT CONVENIENTLY HOLDS SKETCH BOOKS AND OTHER EQUIPMENT. ONE THAT HAS A SHOULDER STRAP MAKES IT POSSIBLE TO SKETCH WITHOUT HAVING TO SET IT DOWN.

9

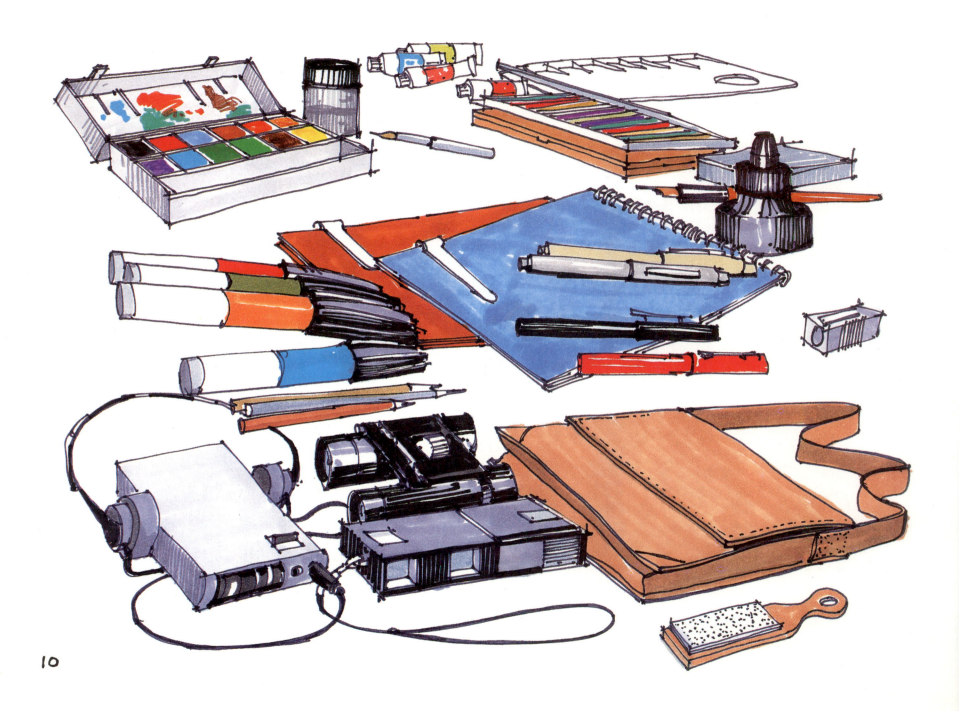

			PAGES
LARGE BARREL ULTRA FINE TIP		GOOD FOR SKETCHING · TENDS TO BLEED · USE ON MARKER PAPER · AVAILABLE IN BLACK AND A VARIETY OF COLORS	15 18 32 38 47 65 75 92
LARGE BARREL MEDIUM TIP		VERSATILE BULLET SHAPED TIP · GOOD FOR LARGER SCALE SKETCHES AND COLOR RENDERINGS OF FINE LINE SKETCHES · OFFERS A VARIETY OF LINE WIDTHS BY USING VARIABLE PRESSURE · AVAILABLE IN BLACK GREY, AND COLOR	48 76 106
LARGE BARREL BROAD TIP		HAS SAME CHARACTERISTICS AS THE POINTED TIP BUT PROVIDES BROAD STROKES AS WELL AS THIN STROKES · ROTATING TIP GIVES A STROKE AND LINE VARIETY AVAILABLE IN BLACK, GREY AND WIDE VARIETY OF COLORS	49 77 94
SMALL BARREL ULTRA FINE TIP		FELT OR NYLON TIP · GOOD FOR SKETCHING · TOO MUCH HEAVY PRESSURE MAKES POINT MUSHY BEFORE INK SUPPLY IS EXHAUSTED. INKS ARE AVAILABLE IN COLOR · INKS ARE WATER-SOLUBLE AND PERMANENT	6 21 26 50 51 66 78 79 95 115 117

			PAGES
SMALL BARREL MEDIUM TIP		GOOD FOR SKETCHING · PROVIDES THICKER LINES · AVAILABLE IN BLACK, GREY AND LIMITED COLORED INKS	52 67 80 89 93 96 113
SMALL BARREL LARGE TIP		SAME CHARACTERISTICS AS THE MEDIUM TIP	16 53 68 81 90 97 98
MEDIUM BARREL EXTRA LARGE TIP		BARREL CARRIES A LIQUID INK SUPPLY · REFILLING CAN BE MESSY · DIFFERENT SHAPED CHANGEABLE TIPS · TIPS CAN BE USED WET OR RELATIVELY DRY · A VERY VERSATILE PEN	118
SMALL BARREL WEDGE TIP		WEDGE SHAPED POINT PROVIDES A VARIABLE LINE WIDTH WHEN ROTATED · NORMALLY USED IN CALLIGRAPHIC WRITING · CAN BE USED IN SKETCHING AS WELL	54 69 82 99 114 142 143
SMALL BARREL NYLON OR FIBER TIP		MAKES A FINE, UNIFORM LINE · THE POINT IS CONSISTANT AND DOESN'T FLATTEN WITH USE OR PRESSURE	4 17 57

			PAGES
SMALL BARREL BALL POINT TIP		MAKES A FINE, UNIFORM LINE - THE POINT IS SOLID AND DOESN'T DETERIORATE WITH USE	5 19 27
MEDIUM BARREL FLEXIBLE PEN POINT		HAS THE SAME CHARACTERISTICS AS A FOUNTAIN PEN · POINT IS SOFTER AND ACTS MUCH LIKE A QUILL PEN POINT · USES INDIA INK · MUST BE USED AND CLEANED FREQUENTLY FOR EASY USE ·	58 85 102 108
MEDIUM BARREL RIGID PEN POINT		GIVES A UNIFORM LINE · INK IS WATER SOLUBLE · ALWAYS FLOWS WHEN NEEDED REGARDLESS OF INTERMITTANT USE	59 86 103 139
SMALL BARREL FLEXIBLE PEN POINT		ACTS LIKE A SKETCH PEN · MUST BE DIPPED IN AN INK RESERVOIR · VARIETY OF INTERCHANGEABLE PEN POINTS AVAILABLE	56 84 101
SMALL BARREL FLEXIBLE PEN POINT		PEN MUST BE FILLED FROM INK RESERVOIR · A VARIETY OF POINTS ARE AVAILABLE FROM FINE TO VERY BROAD · HOLDS MORE INK THAN A QUILL POINT	60 87 104 109

			PAGES
MEDIUM BARREL RIGID PEN POINT		CONTAINS A WATERPROOF INK RESERVOIR · SOMETIMES CLOGS IF NOT IN CONTINUOUS USE · MUST BE HELD NEAR VERTICAL FOR DRAWING AND PROPER INK FLOW · HAS A VARIETY OF POINT SIZES PROVIDING FOR VARIOUS LINE WIDTHS	55 83 100 107
SMALL BARREL FLEXIBLE BRUSH TIP		COMES IN VARIOUS SIZES · TAKES SOME DEGREE OF SKILL TO USE PROPERLY · USED FOR SKETCHES AS WELL AS LAYING IN WASHES	61 63 70 88 105 110
MEDIUM BARREL FLEXIBLE BRUSH TIP		HAS BUILT IN INK RESERVOIR · OFTEN DRIES OUT WITH LACK OF CONTINUED USE · COMES IN BLACK AND A LIMITED COLOR RANGE	71
SMALL BARREL RIGID POINT		WOOD PENCIL · AVAILABLE IN VARIOUS COLORS AND TYPES OF MEDIA SUCH AS CARBON, GRAPHITE, CHARCOAL, WAXED BASED, PASTEL AND OTHER CONSISTANCIES	31 45 62 91 111 113 114 115
SMALL BARREL ADJUSTABLE POINT		HAS ADJUSTABLE LEAD EXPOSURE · CAN USE A VARIETY OF LEAD TYPES INCLUDING BLACK AND COLOR.	113

14

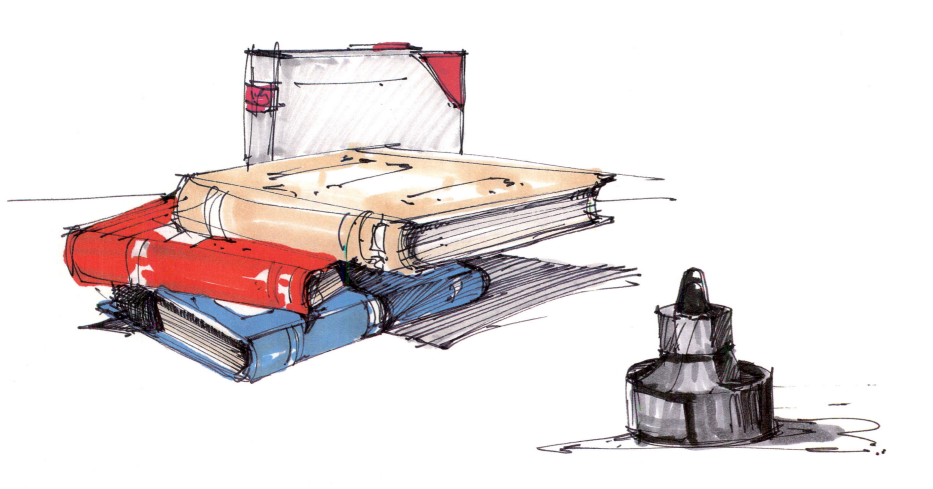

FINE TIP FELT PEN AND COLORED MARKER

SKETCHING POINTERS

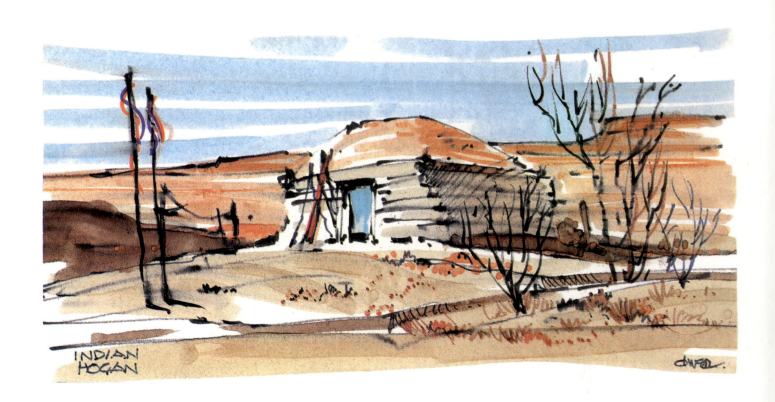

INDIAN
HOGAN

IN ALL SKETCHES THERE ARE UNDERLYING PRINCIPLES IN DRAWING THAT SHOULD BE UNDERSTOOD TO MAKE THEM AS EFFECTIVE AS POSSIBLE. THE FOLLOWING MAJOR POINTS ARE COVERED IN THE SUCCEEDING PAGES:

A. THE CONSTRUCTION OF A SKETCH

B. PERSPECTIVE AND OTHER DEVICES USED TO ACHIEVE A THREE DIMENSIONAL APPEARANCE

C. TONES, TEXTURES, SHADES AND SHADOWS

D. COMPOSITION

THESE POINTS ARE INTENDED AS REMINDERS AND ARE FAR FROM BEING DEFINITIVE.

ONE OF THE MOST IMPORTANT ASPECTS OF A GOOD SKETCH IS THE ARTIST'S ABILITY TO CAPTURE THE PROPER PROPORTION OF THE SUBJECT. THIS CAN ONLY BE ACCOMPLISHED THROUGH MANY HOURS OF TRAINING THE EYE TO SEE AND THE HAND TO RECORD WITH CONSTANT VERIFICATION AND CORRECTION UNTIL IT BECOMES INSTINCTIVE.

HAVING MASTERED THE PRINCIPLES INVOLVED IN THESE CATEGORIES THERE IS THE OPTION TO USE CREATIVE LICENSE TO MODIFY IN ORDER TO CREATE A PERSONAL STYLE IN SKETCHING. THIS IS THE EXCITEMENT AND REWARD IN SKETCHING.

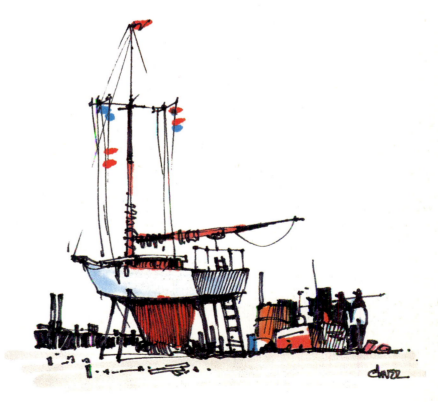

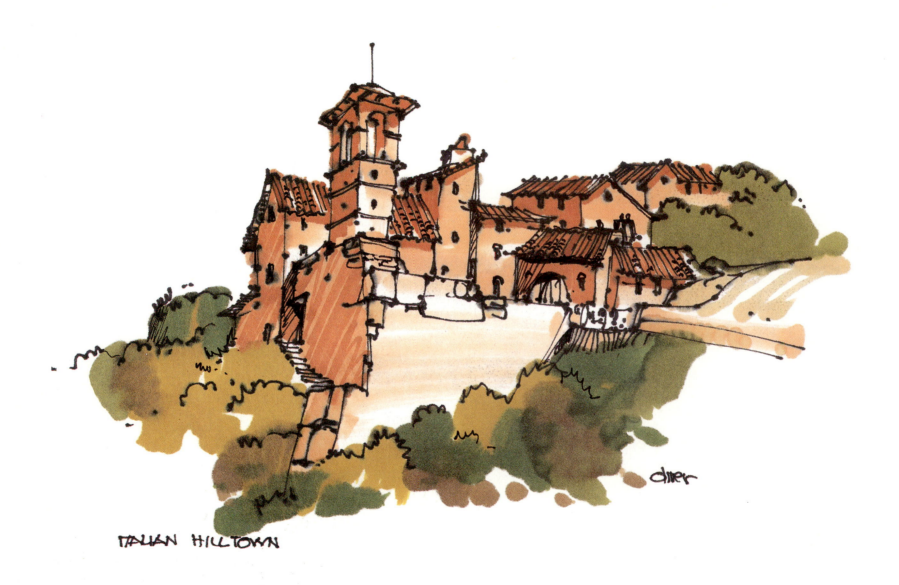

ITALIAN HILLTOWN

18

TONES

TEXTURES

SHADES
AND
SHADOWS

THE SINGLE LINE SKETCH CAN BE AN END IN ITSELF. HOWEVER, BY ADDING TEXTURES, TONES, SHADES AND SHADOWS THE THREE DIMENSIONAL EFFECT CAN BE CONSIDERABLY ENHANCED. THESE QUALITIES ARE USUALLY ACCOMPLISHD THROUGH A VARIETY OF STROKE TECHNIQUES OF THE PEN AND PENCIL. THESE SAME EFFECTS CAN BE ACHIEVED USING VALUE CHANGES IN THE APPLIED COLORS.

IN THE PAGES TO FOLLOW VARIOUS TECHNIQUES WILL BE ILLUSTRATED TO FURTHER CREATE THE THREE DIMENSIONAL ILLUSION IN THE SKETCH.

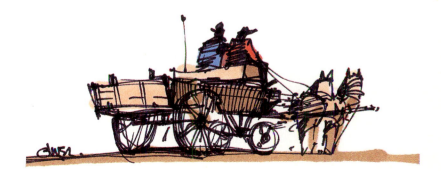

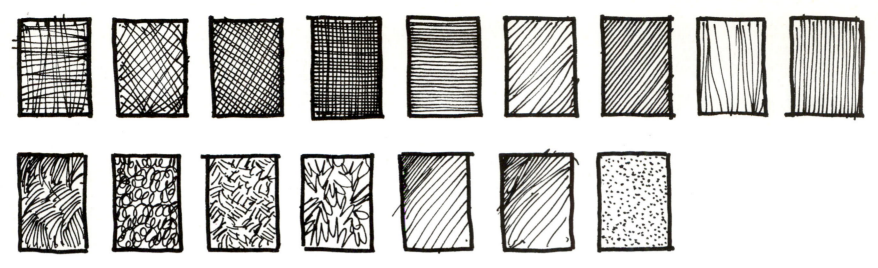

PEN

A SAMPLING OF VARIOUS STROKES WITH PEN AND PENCIL TO ACHIEVE TONAL AND TEXTURED AREAS IN A SKETCH

PENCIL

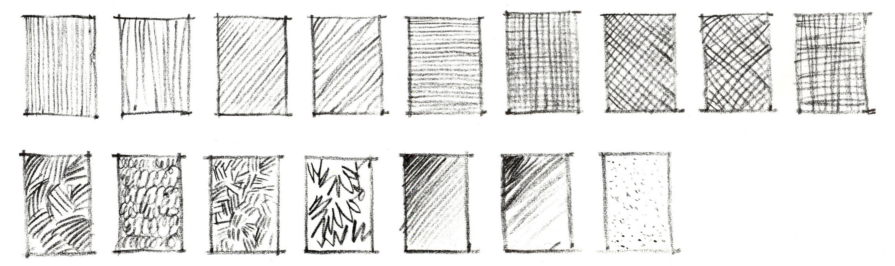

- A DEMONSTRATION OF VARIOUS STROKES TO DEPICT TEXTURES, MATERIALS AND TONAL AREAS

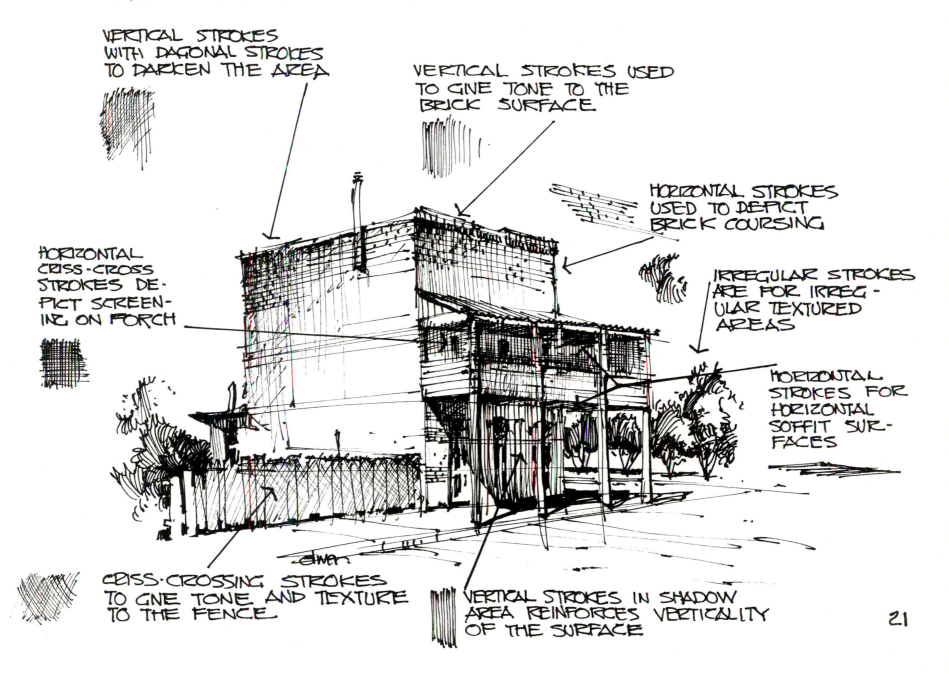

VERTICAL STROKES WITH DIAGONAL STROKES TO DARKEN THE AREA

VERTICAL STROKES USED TO GIVE TONE TO THE BRICK SURFACE.

HORIZONTAL STROKES USED TO DEPICT BRICK COURSING

HORIZONTAL CRISS-CROSS STROKES DEPICT SCREENING ON PORCH

IRREGULAR STROKES ARE FOR IRREGULAR TEXTURED AREAS

HORIZONTAL STROKES FOR HORIZONTAL SOFFIT SURFACES

CRISS-CROSSING STROKES TO GIVE TONE AND TEXTURE TO THE FENCE

VERTICAL STROKES IN SHADOW AREA REINFORCES VERTICALITY OF THE SURFACE

21

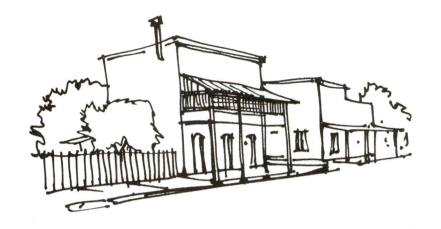

NO TONAL VALUES

IN ADDITION TO PERSPECTIVE TECHNIQUES BEING USED TO CREATE DEPTH IN A SKETCH, OVERLAPPING PLANES MAY ALSO BE USED TO CREATE DEPTH. THESE ILLUSTRATIONS SERVE TO ILLUSTRATE THESE PRINCIPLES.

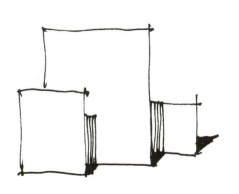

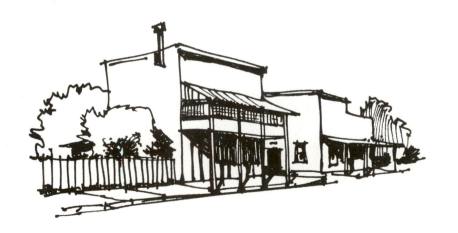

SHADE AND SHADOW TONES

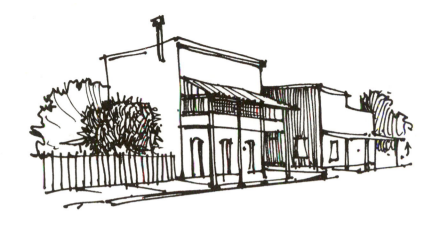

TONAL CHANGE
ONLY.

ALL THE SKETCHES SHOWN ON THESE TWO PAGES ARE COMPLETE
IN THEMSELVES. THE ADDITION OF TONAL VALUES AND SHADES
AND SHADOWS ONLY TEND TO ENHANCE THE THREE DIMENSIONAL
QUALITY OF THE SUBJECT MATTER.

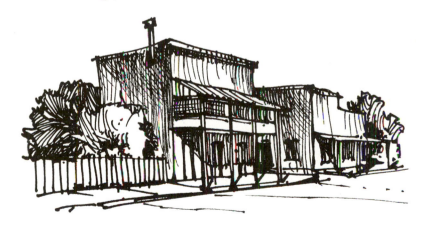

TONAL CHANGE
AND SHADES
AND SHADOWS

23

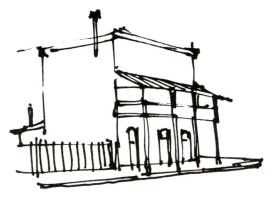

WHITE

THE EFFECT OF TONAL TREATMENT ON A SKETCH

EACH SKETCH AT THE LEFT IS ADEQUATE IN ITSELF BUT IT CAN BE ENHANCED BY THE FULL RANGE OF VALUES FROM WHITE TO GREY TO BLACK

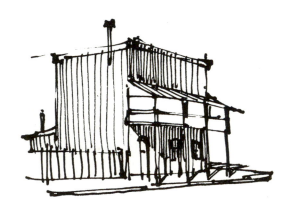

MIDDLE VALUE GREY TONE

GREY IS THE DOMINANT TONE

BLACK AND WHITE ARE THE ACCENTS

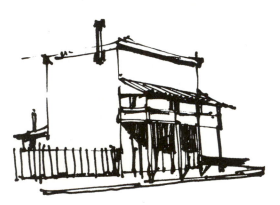

BLACK

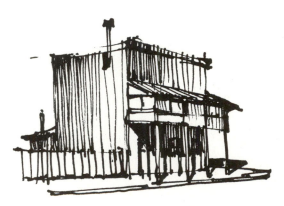

TOTAL TONAL RANGE

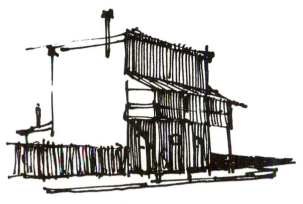

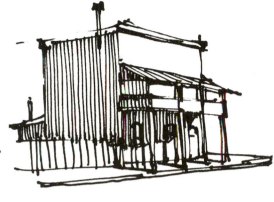

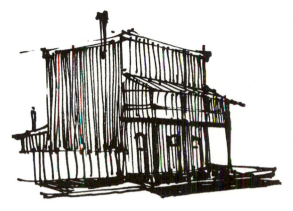

FROM THE LEFT

FROM THE RIGHT ABOVE

FROM THE REAR.

THESE EXAMPLES DEMONSTRATE THE EFFECTS CREATED
BY THE CHANGE IN DIRECTION OF THE LIGHT SOURCE.

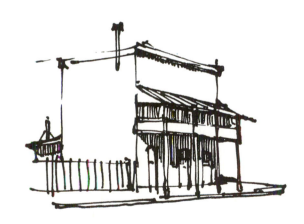

FROM THE
LEFT ABOVE

TONE EMPHASIS ON
THE LOWER PART
OF THE BUILDING

TONE EMPHASIS ON
THE UPPER PART OF
THE BUILDING.

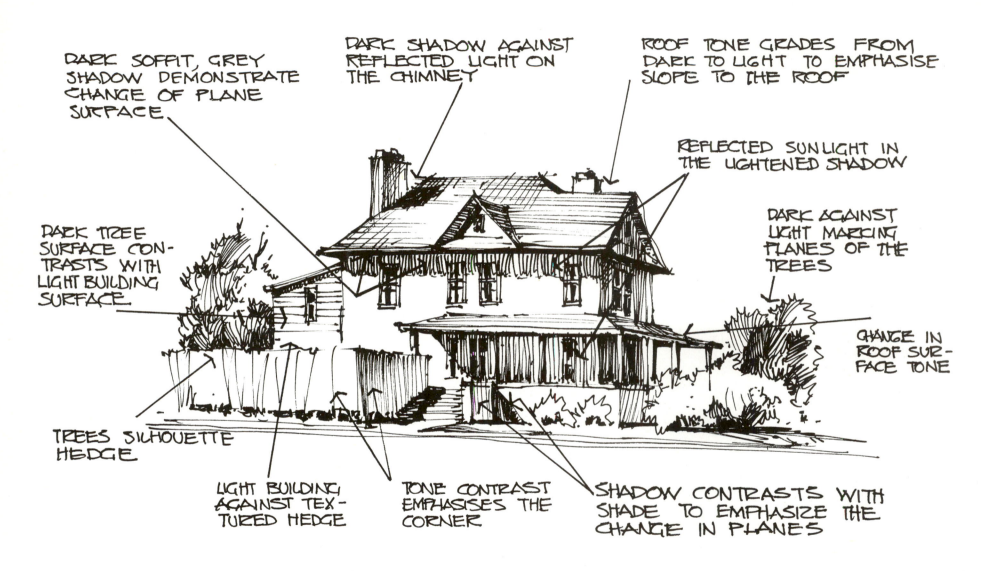

DARK SOFFIT, GREY SHADOW DEMONSTRATE CHANGE OF PLANE SURFACE.

DARK SHADOW AGAINST REFLECTED LIGHT ON THE CHIMNEY

ROOF TONE GRADES FROM DARK TO LIGHT TO EMPHASISE SLOPE TO THE ROOF

REFLECTED SUNLIGHT IN THE LIGHTENED SHADOW

DARK TREE SURFACE CONTRASTS WITH LIGHT BUILDING SURFACE.

DARK AGAINST LIGHT MARKING PLANES OF THE TREES

CHANGE IN ROOF SURFACE TONE

TREES SILHOUETTE HEDGE

LIGHT BUILDING AGAINST TEXTURED HEDGE

TONE CONTRAST EMPHASISES THE CORNER

SHADOW CONTRASTS WITH SHADE TO EMPHASIZE THE CHANGE IN PLANES

THE SKETCH ABOVE ILLUSTRATES THE USE OF TONAL VALUES TO EMPHASIZE CORNERS, PLANES, SHADES AND SHADOWS.

26

SKETCH CONSTRUCTION

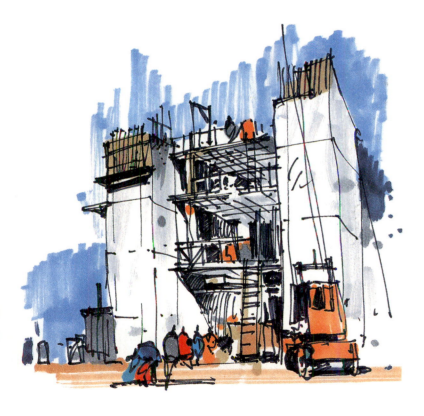

A SKETCH IS NOTHING MORE THAN A COLLECTION OF LINES ASSEMBLED IN SUCH A WAY AS TO DEFINE A SHAPE. THE SHAPE IS FURTHER ENHANCED BY THE ADDITION OF DETAIL. AT THIS POINT, THE SKETCH CAN EXIST AS AN END IN ITSELF. TO FURTHER ELABORATE THE SKETCH, TONAL VALUES, SHADES AND SHADOWS CAN BE ADDED TO THE SKETCH. NOT TO BE FORGOTTEN IN THE COMPLETION OF THE SKETCH ARE THE SUPPORTING COMPOSITION ELEMENTS OF A FOREGROUND, MIDDLEGROUND AND BACKGROUND. FINALLY COLOR IS ADDED TO PROVIDE THE ULTIMATE TOUCH.

NONE OF THIS IS WORTHWHILE HOWEVER, IF AT FIRST THE BASIC SHAPE OF SKETCH IS NOT TESTED FOR PROPORTION AND PERSPECTIVE. IF IT IS IN ERROR AT THIS STAGE AND NOT CORRECTED THEN YOU END UP WITH A NICE SKETCH OF AN ERROR. THIS IS NOT ONLY UNREWARDING BUT A WASTE OF TIME.

27

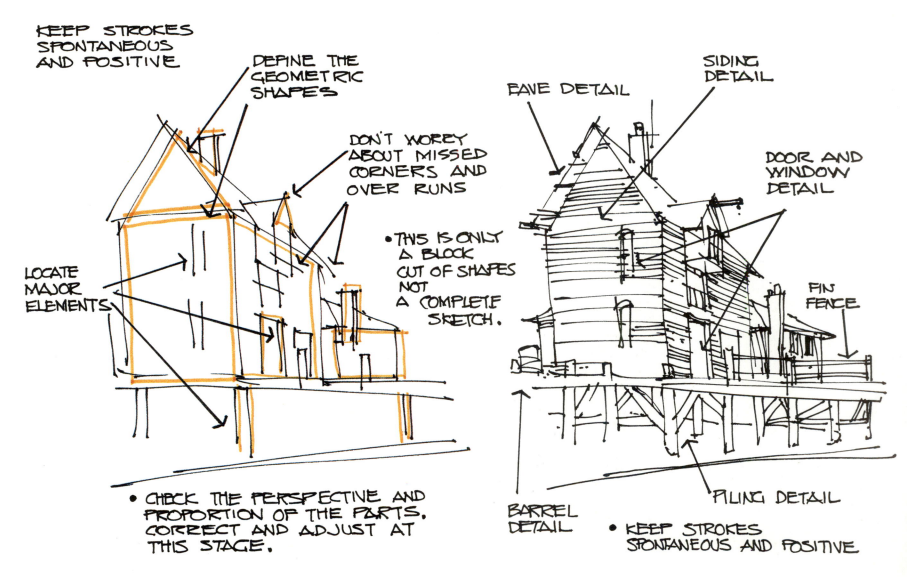

KEEP STROKES
SPONTANEOUS
AND POSITIVE

DEFINE THE
GEOMETRIC
SHAPES

DON'T WORRY
ABOUT MISSED
CORNERS AND
OVER RUNS

• THIS IS ONLY
A BLOCK
CUT OF SHAPES
NOT
A COMPLETE
SKETCH.

LOCATE
MAJOR
ELEMENTS

EAVE DETAIL

SIDING
DETAIL

DOOR AND
WINDOW
DETAIL

FIN
FENCE

PILING DETAIL

BARREL
DETAIL

• KEEP STROKES
SPONTANEOUS AND POSITIVE

• CHECK THE PERSPECTIVE AND
PROPORTION OF THE PARTS.
CORRECT AND ADJUST AT
THIS STAGE.

28

LINES DEFINING SHAPES

DETAIL ADDED TO SHAPES

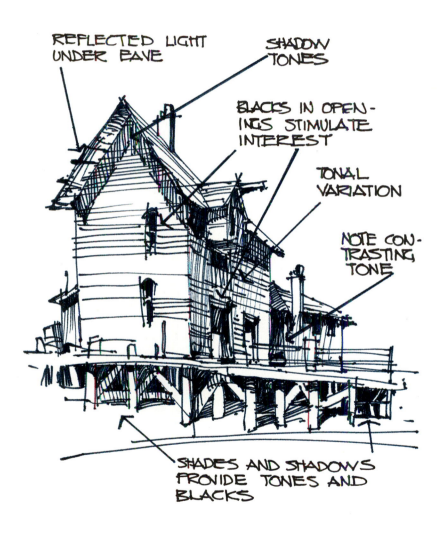

REFLECTED LIGHT UNDER EAVE

SHADOW TONES

BLACKS IN OPEN-INGS STIMULATE INTEREST

TONAL VARIATION

NOTE CON-TRASTING TONE

SHADES AND SHADOWS PROVIDE TONES AND BLACKS

TONE PLUS BLACK

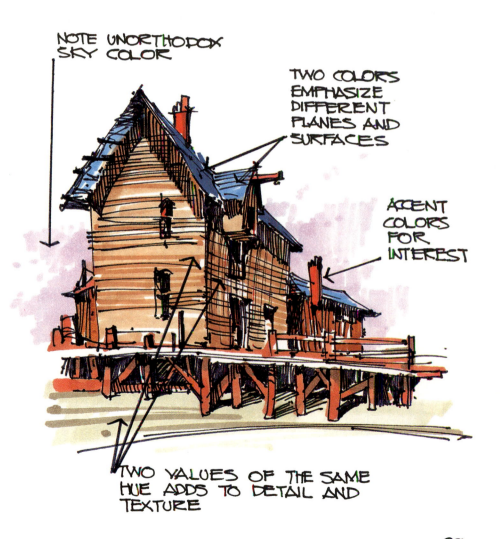

NOTE UNORTHODOX SKY COLOR

TWO COLORS EMPHASIZE DIFFERENT PLANES AND SURFACES

ACCENT COLORS FOR INTEREST

TWO VALUES OF THE SAME HUE ADDS TO DETAIL AND TEXTURE

COLOR ADDED

29

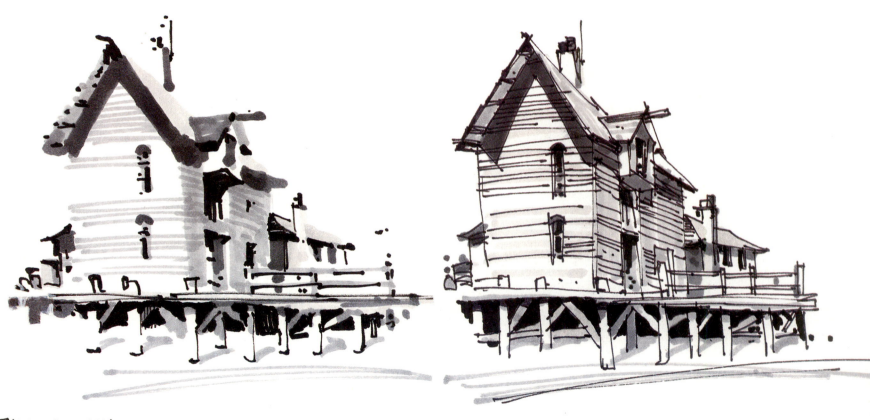

THE SKETCH IS DEFINED BY TONE
ONLY WITH A CHANGE IN VALUE
30 OF THE TONES CREATING THE
THREE DIMENSIONAL APPEARANCE.

THE SKETCH IS DEFINED BY LINE
TONE AND A CHANGE IN VALUE
OF THE TONES.

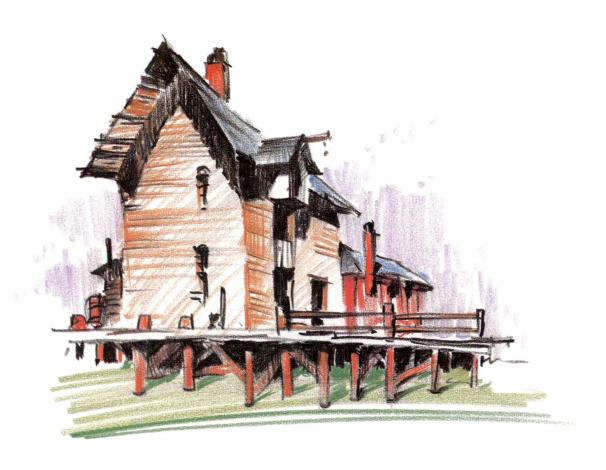

THIS SKETCH IS DEFINED BY LINE, TONE
AND A CHANGE IN VALUE OF THE COLORS.
THIS IS ACCOMPLISHED IN COLOR PLUS
BLACK

THIS IS A COLORED PENCIL SKETCH

31

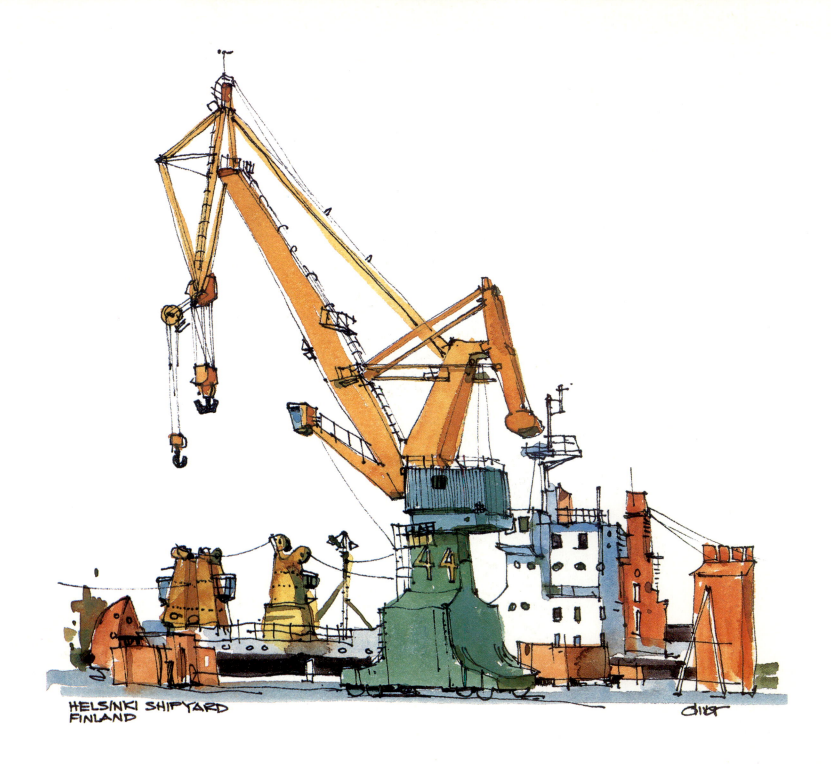

HELSINKI SHIPYARD
FINLAND

32

COMPOSITION

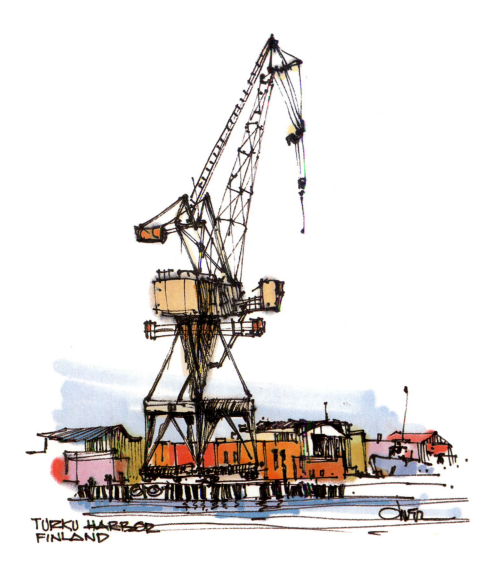

TURKU HARBOR
FINLAND

THE PRINCIPLES OF COMPOSITION IN SKETCHING ARE SOMEWHAT LESS DEMANDING THAN THOSE ENCOUNTERED IN CREATING A FINISHED ART WORK. SKETCHING IS PRIMARILY A QUICK WAY TO RECORD A SUBJECT OR SCENE FOR FUTURE REFERENCE, IN MANY CASES, WITHOUT THE RESTRICTIONS OF FRAME OR FORMAT. THIS FORCES THE SUBJECT MATTER TO BE COMPOSED WITHIN ITSELF. IT IS WITH THIS IN MIND THAT, AMONG THE MANY PRINCIPLES OF COMPOSITION, THERE ARE THREE ADDRESSED THAT ARE OF MAJOR IMPORTANCE TO THE COMPOSITION OF SKETCHES:

A. COMPOSITION OF FOREGROUND, MIDDLEGROUND, AND BACKGROUND.

B. COMPOSITION OF VALUES

C. COMPOSITION OF VITAL ELEMMENTS BORROWED FROM ADJACENT AREAS OF THE SKETCH SCENE

THE FOLLOWING PAGES ILLUSTRATE THESE POINTS.

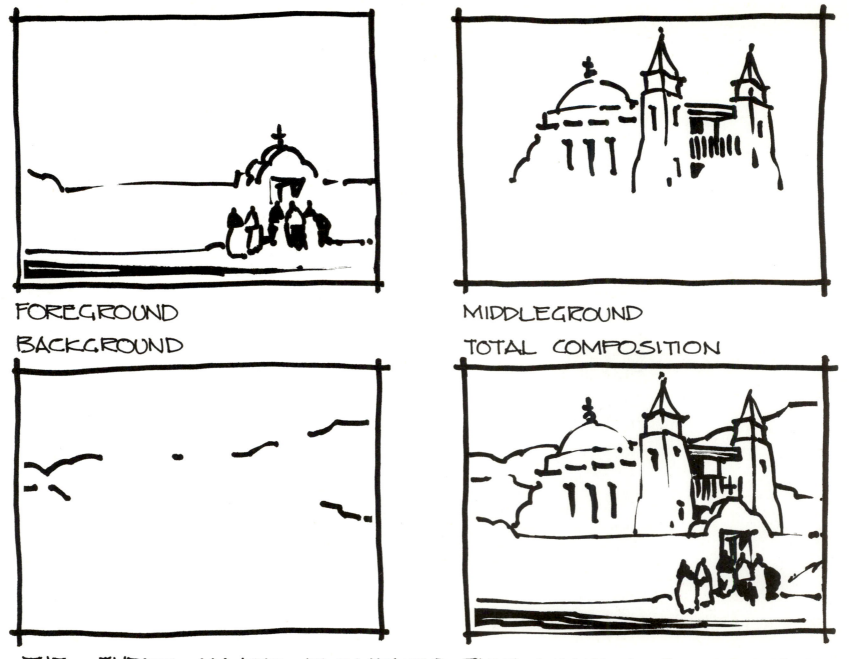

FOREGROUND

MIDDLEGROUND

BACKGROUND

TOTAL COMPOSITION

34 THE THREE MAJOR ELEMENTS THAT MAKE A COMPOSITION

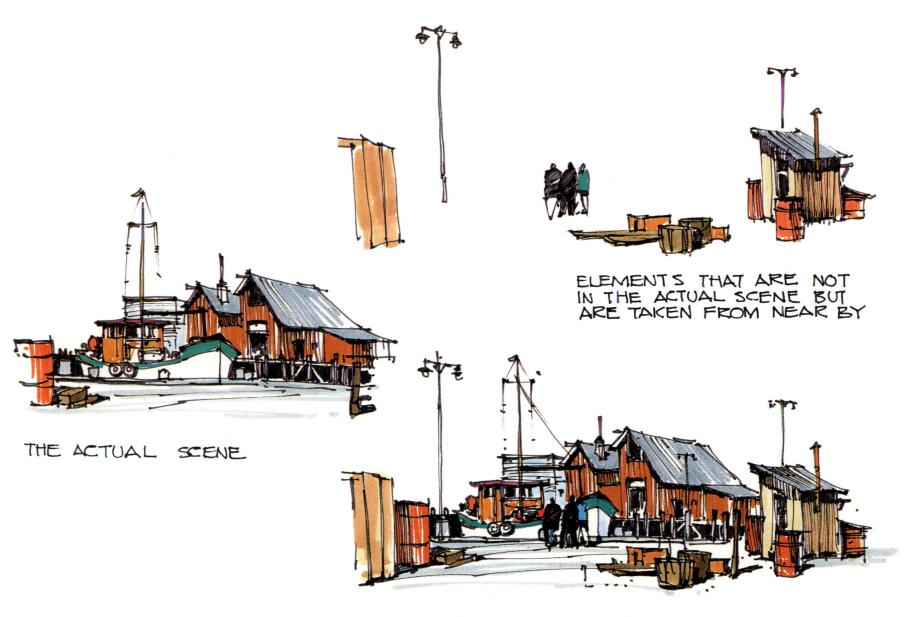

ELEMENTS THAT ARE NOT
IN THE ACTUAL SCENE BUT
ARE TAKEN FROM NEAR BY

THE ACTUAL SCENE

ACTUAL SCENE ENHANCED BY THE
ADDITION OF BORROWED ELEMENTS
TAKEN FROM NEAR BY

35

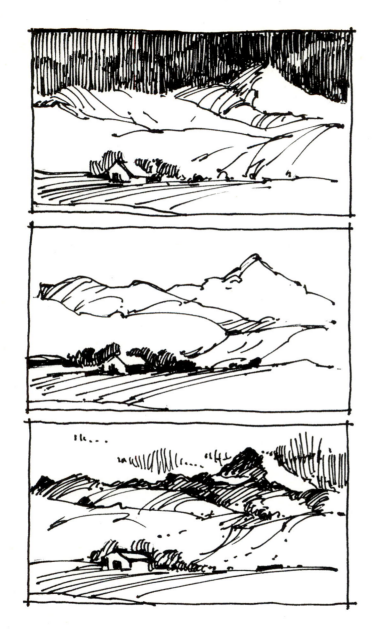
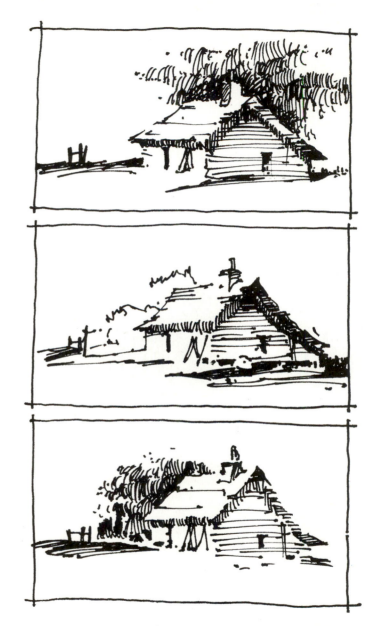

THE SKETCHES ABOVE SHOW HOW SHIFTING THE HIGH CONTRAST AREAS CAN SHIFT THE AREA OF INTEREST.

LINE BLOCK OUT
OF SHAPES

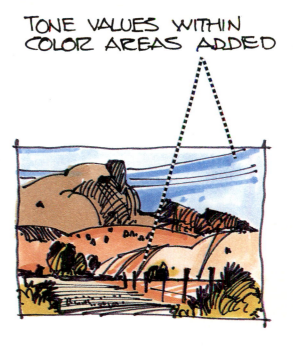

TONE VALUES WITHIN
COLOR AREAS ADDED

COLOR ADDED TO
TONE VALUE SKETCH

DETAIL ADDED TO
SHAPES

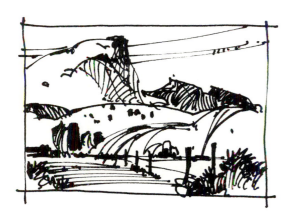

TONE VALUES PLUS
BLACK ACCENTS
ADDED

SIMPLE FOUR STAGE LANDSCAPE CONSTRUCTION

37

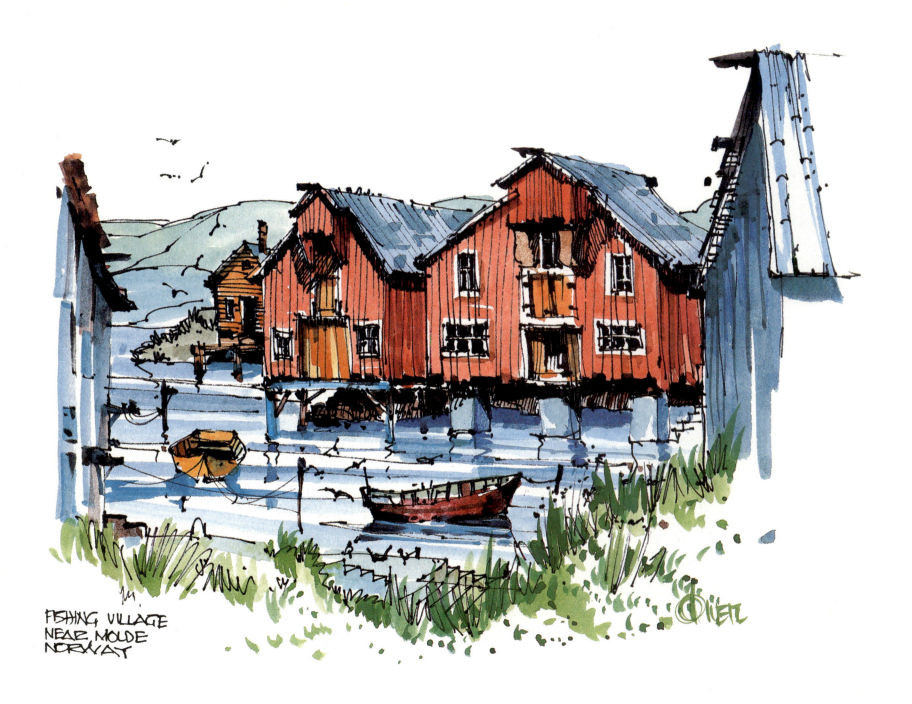

FISHING VILLAGE
NEAR MOLDE
NORWAY

38

PERSPECTIVE

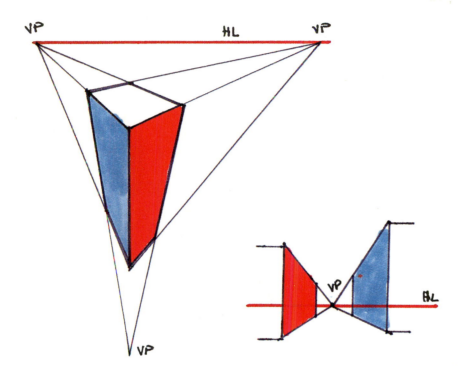

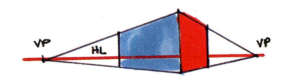

PERSPECTIVE IS USED TO REP-
RESENT DEPTH AND DIMENSION
IN A SKETCH. THERE ARE A FEW
VERY IMPORTANT PRINCIPLES
TO KEEP IN MIND IN ITS APPLICAT-
ION. THESE ARE LISTED BELOW
AND GRAPHICALLY ILLUSTRATED IN
THE FOLLOWING PAGES.

1. THE IMAGINARY HORIZON LINE
 IS ALWAYS COINCIDENT WITH
 THE EYE LEVEL.

2. THE VANISHING POINT OR POINTS
 ARE ALWAYS ON THE HORIZON
 LINE.

3. THERE ARE EITHER ONE, TWO,
 OR THREE VANISHING POINTS
 DEPENDING UPON THE LOCATION
 OF THE VIEWER AND THE RE-
 LATIONSHIP OF THE OBJECTS
 TO THE PLANE OF VISION.

THREE POINT PERSPECTIVE IS
SELDOM USED IN SKETCHING, AND
IT IS NOT COVERED HERE.

39

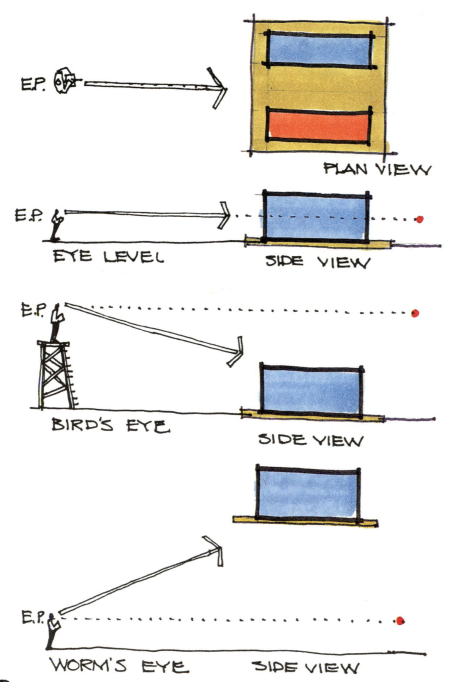

E.P. → PLAN VIEW

E.P. EYE LEVEL — SIDE VIEW

E.P. BIRD'S EYE — SIDE VIEW

E.P. WORM'S EYE — SIDE VIEW

ONE POINT PERSPECTIVE

E.P. – EYE POINT
V.P. – VIEW POINT
H.L. – HORIZON LINE

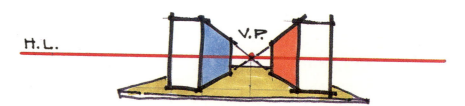

H.L. V.P.

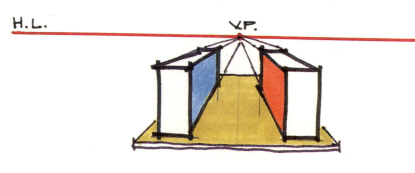

H.L. V.P.

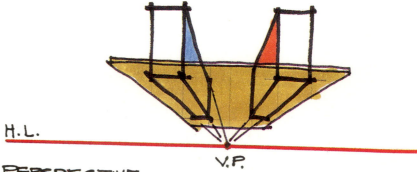

H.L. V.P.

PERSPECTIVE VIEWS

40

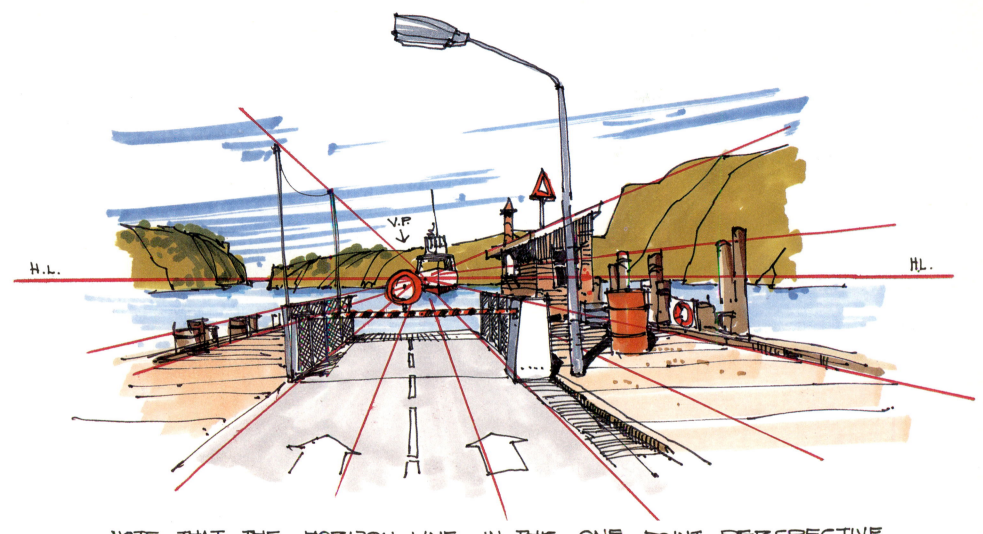

NOTE THAT THE HORIZON LINE IN THIS ONE POINT PERSPECTIVE COINCIDES WITH THE TRUE HORIZON.

THE HEIGHT OF THE EYE OF THE PERSON SKETCHING THE SCENE IS AT APPROXIMATELY FIVE FEET OFF OF THE GROUND, THUS THE HORIZON LINE CUTS THROUGH POINTS IN THE SKETCH AT THAT HEIGHT SINCE THE HORIZON LINE AND EYE POINT ALWAYS CO-INCIDE, AND THE VANISHING POINT IS ALWAYS ON THE HORIZON LINE.

41

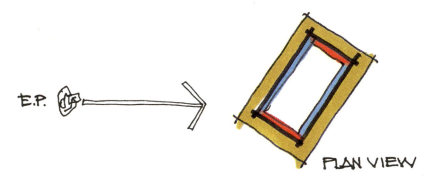

E.P. PLAN VIEW

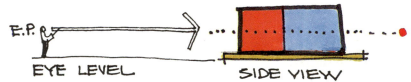

EYE LEVEL SIDE VIEW

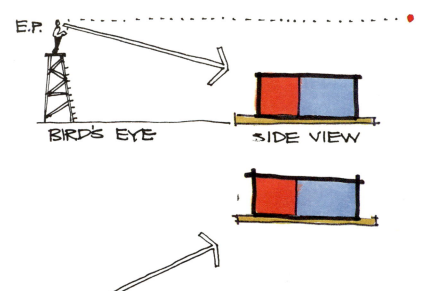

E.P.

BIRD'S EYE SIDE VIEW

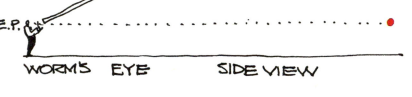

E.P.

WORM'S EYE SIDE VIEW

TWO POINT PERSPECTIVE

E.P. - EYE POINT
V.P. - VIEW POINT
H.L. - HORIZON LINE

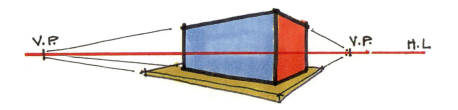

V.P. V.P. H.L.

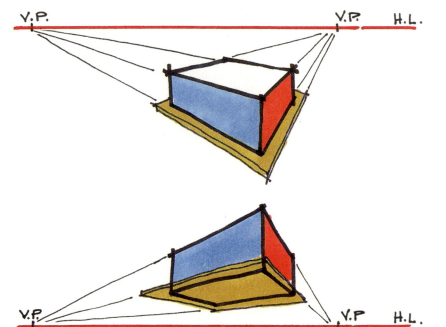

V.P. V.P. H.L.

V.P. V.P. H.L.

PERSPECTIVE VIEWS

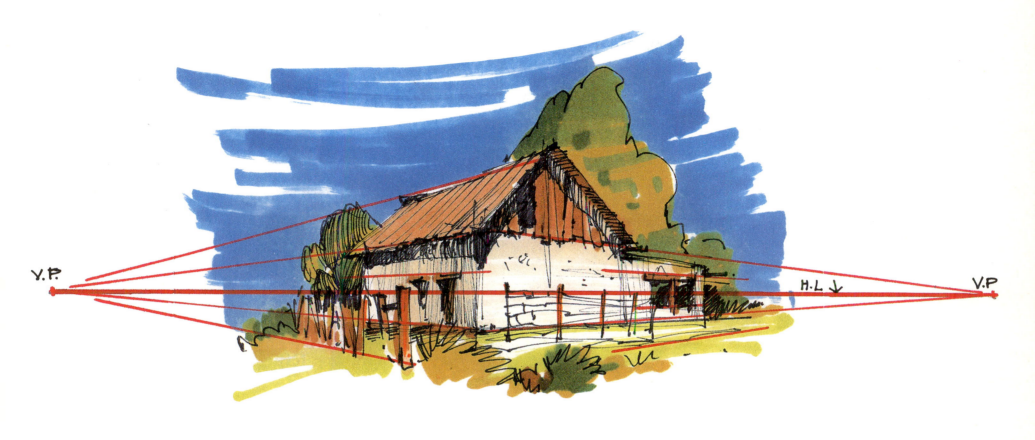

V.P. H.L ↓ V.P

THE BUILDING IN THIS SKETCH SITS AT ABOUT AN ANGLE OF 45°
TO THE VIEWER. THUS THE VANISHING POINTS ARE NEAR EQUI-
DISTANT FROM THE CENTER.

NOTE THAT THE HORIZON LINE CUTS ACROSS THE BUILDING ABOUT
FIVE FEET OFF THE GROUND WHICH COINCIDES WITH THE HEIGHT
OF THE EYE OF THE PERSON SKETCHING THE SCENE.

4 TRANSPARENT AND OPAQUE WATERCOLOR

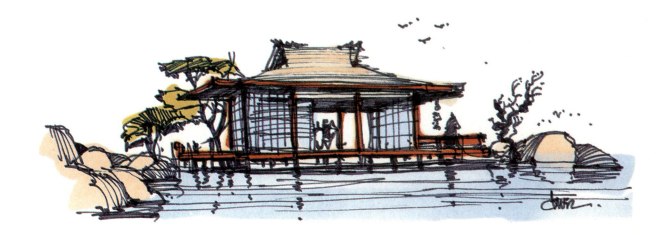

TRANSPARENT WATERCOLOR

THE WATERCOLORS USED IN THE SKETCHES IN THIS BOOK ARE FROM THE SMALL TWELVE PAN WATERCOLOR KIT MARKETED BY WINSOR AND NEWTON. THE ORIGIONAL PAN COLORS WERE REPLACED WITH COLORS FROM TUBES IN ORDER TO PROVIDE A MORE PERSONAL CHOICE. THIS KIT IS VERY COMPACT CONSIDERING THE WIDE VARIETY OF COLORS THAT CAN BE OBTAINED BY MIXING.

THESE PAINTS ARE USED MORE FOR TOUCHING IN COLOR THEREFORE MOST ANY GOOD QUALITY SKETCH PAPER OR WATERCOLOR PAPER CAN BE USED. WATER IS USED SPARINGLY AND DOES NOT CAUSE SERIOUS PAPER BUCKLING. DIFFERENT SURFACE CHARACTERISTICS OF THE PAPER, HARD SURFACE OR ABSORBANT, WILL RESULT IN DIFFERENT EFFECTS.

BECAUSE THE PAINTS ARE WATER SOLUBLE THEY CAN BE EASILY REVIVED AND READIED BY THE ADDITION OF WATER. THE COLORS CAN BE MIXED IN THE PALLETTE OR BLENDED ON THE WET SURFACE OF THE PAPER. GLAZING ON TRANS-PARENT COLOR OVER ANOTHER CAN RESULT IN A NEW COLOR. OVERLAYING DEEPER VALUES OF THE SAME COLOR WILL ADD TO THE SURFACE QUALITY. THE USE OF THE COLORS SHOULD BE JUDICIOUS AND NOT OVERDONE.

CAUTION SHOULD BE TAKEN WHEN APPLYING WATERCOLOR TO A SKETCH DONE WITH SOLUBLE INK. THE WATER DISSOLVES THE INK AND THE RESULTS, IF CONTROLLED, COULD BE ADVANTAGES, BUT IF NOT, CAN BE DISASTEROUS.

45

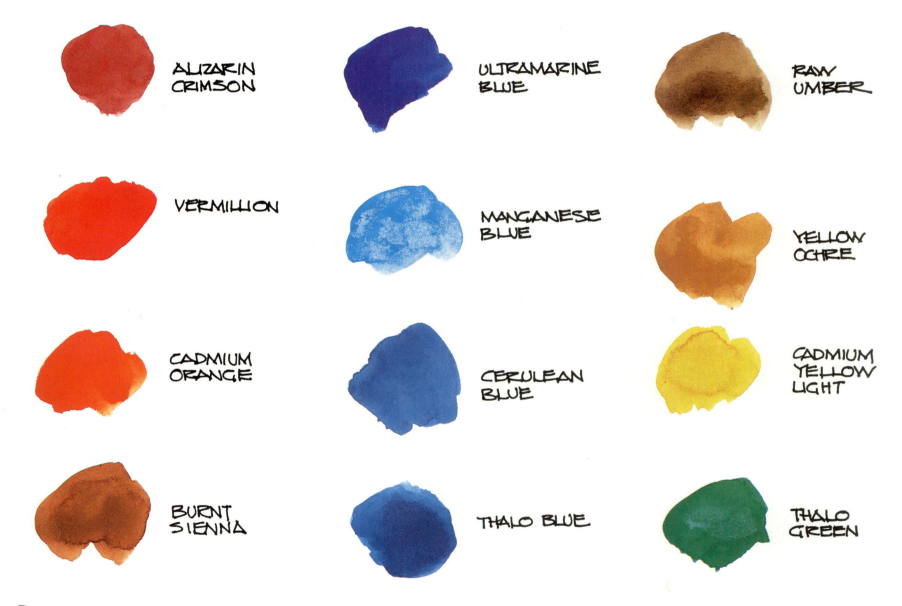

ALIZARIN CRIMSON

ULTRAMARINE BLUE

RAW UMBER

VERMILLION

MANGANESE BLUE

YELLOW OCHRE

CADMIUM ORANGE

CERULEAN BLUE

CADMIUM YELLOW LIGHT

BURNT SIENNA

THALO BLUE

THALO GREEN

THESE ARE RECOMMENDED REPLACEMENT COLORS TO A WINSOR AND NEWTON SMALL 12 PAN WATERCOLOR KIT. THESE ARE TUBE WATERCOLORS.

46

OF COURSE, THE ORIGIONAL COLORS ARE SATISFACTORY IF THEY SUIT YOUR PURPOSE.

KEEP YOUR COLOR
PALLETTE SIMPLE.

REPEAT COLOR THROUGH-
OUT THE SKETCH.

DON'T ELABORATE THE
TREE DETAIL BECAUSE
THE BUILDINGS ARE THE
CENTER OF INTEREST.

THE PEOPLE AND STREET
SCAPE PROVIDE ANIMAT-
ION AND ENVIRONMENTAL
CONTEXT TO THE SKETCH.

DON'T OVER DETAIL SINCE
IT IS ONLY INTENDED TO
BE A QUICK SKETCH OR
AN IMPRESSION.

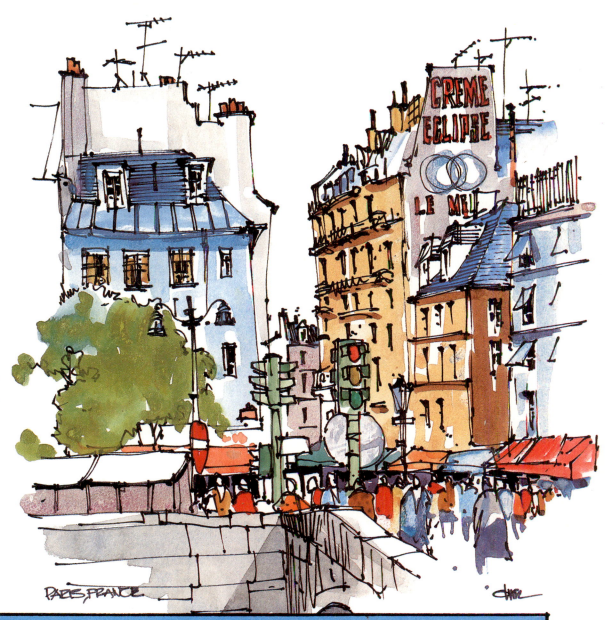

PARIS FRANCE

LARGE BARREL MARKER - ULTRA FINE TIP - DRAWING PAPER 47

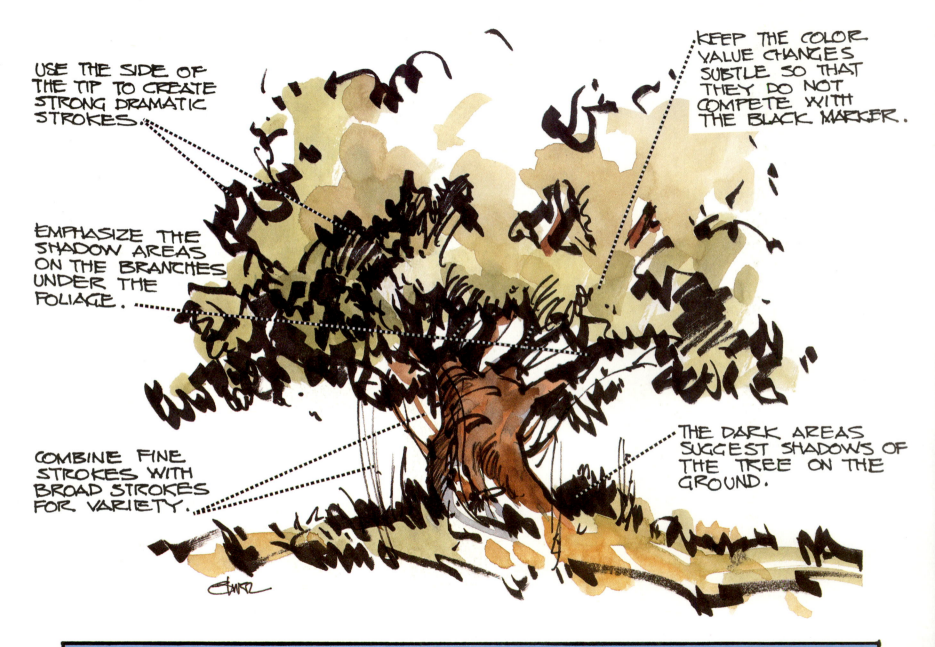

USE THE SIDE OF THE TIP TO CREATE STRONG DRAMATIC STROKES.

KEEP THE COLOR VALUE CHANGES SUBTLE SO THAT THEY DO NOT COMPETE WITH THE BLACK MARKER.

EMPHASIZE THE SHADOW AREAS ON THE BRANCHES UNDER THE FOLIAGE.

COMBINE FINE STROKES WITH BROAD STROKES FOR VARIETY.

THE DARK AREAS SUGGEST SHADOWS OF THE TREE ON THE GROUND.

48 | LARGE BARREL MARKER — MEDIUM TIP — SKETCHING PAPER

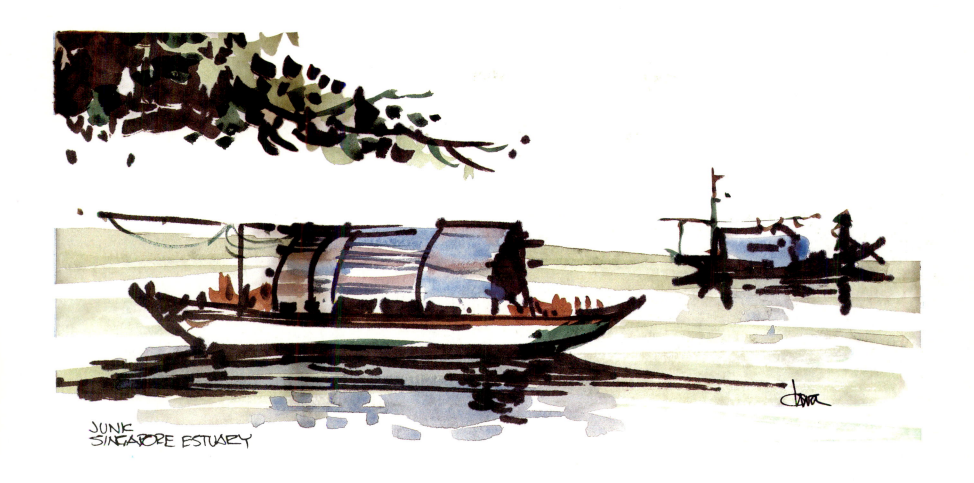

JUNK
SINGAPORE ESTUARY

THE NATURE OF THE
BROAD TIP PEN KEEPS
THE SKETCH DIRECT
AND SIMPLE.

THE SHAPES OF THE
OBJECTS ARE MOST
IMPORTANT SINCE THEY
ARE CREATED WITH
SO FEW STROKES.

THE USE OF BLACKS
ENHANCE THE CRISPNESS
AND IMPACT OF THE
SKETCH.

LARGE BARREL MARKER — BROAD TIP — WATERCOLOR PAPER 49

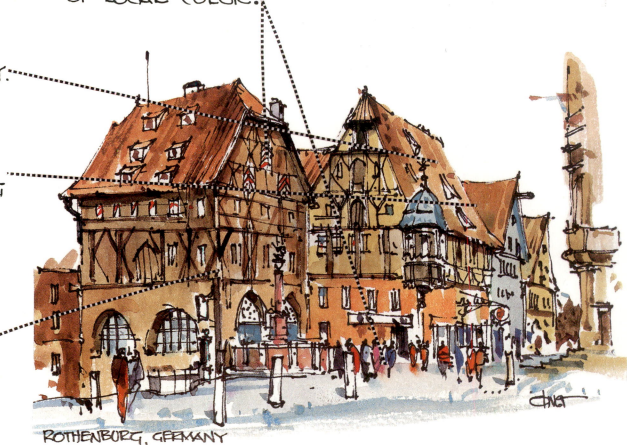

VARY THE VALUES OF
A COLOR WITHIN AN
AREA TO CREATE
INTEREST AND VITALITY.

IMPORTANT ADDITIONS
OF LOCAL COLOR.

VALUE CHANGES OF
COLOR ON OVERLAPPING
PLANES HELP TO
VISUALLY SEPARATE
THEM.

THE COLORS CHANGE
IN VALUE AT POINTS
WHERE PLANES
CHANGE DIRECTION.

THE FINE TIP OF THE
PEN FORCES THE
COLOR TO PLAY A
DOMINANT ROLE.

ROTHENBURG, GERMANY

SMALL BARREL MARKER — FINE TIP — WATERCOLOR PAPER

NOTE THE DOMINANCE OF ONE
COLOR IN EACH SKETCH, GREY
OR BEIGE. THIS UNIFIES THE
COMPOSITION. SMALL DETAIL
AREAS AND COLOR ACCENTS
PROVIDE BALANCE AND CREATE
A CENTER OF INTEREST.

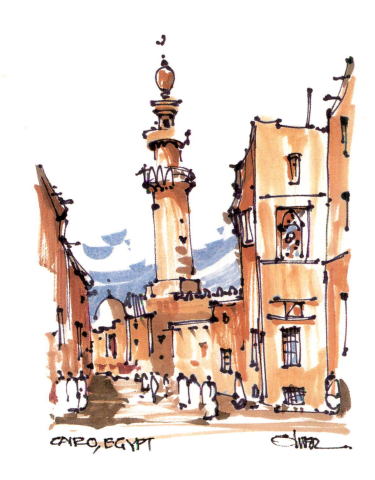

CAIRO, EGYPT

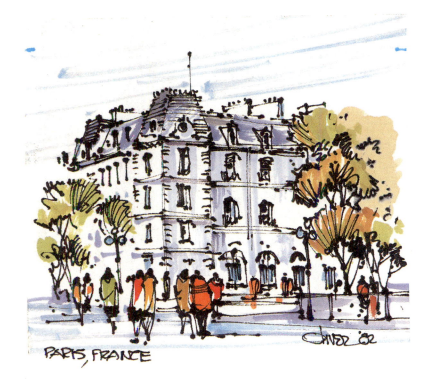

PARIS, FRANCE

SINCE THE PAPER IS SO ABSORBANT,
LIKE A BLOTTER, PEN AND BRUSH
STROKES MUST BE SWIFT TO AVOID
BLOBS. THIS MAKES FOR A VERY
QUICK SKETCH.

THE RED AND BLUE
COLORS ADJACENT
TO EACH OTHER
CREATE A TENSION.

BECAUSE SO MUCH
IS GOING ON IN THE
SKETCH THE CHOICE
OF COLORS WAS
KEPT SIMPLE BUT
STRONG.

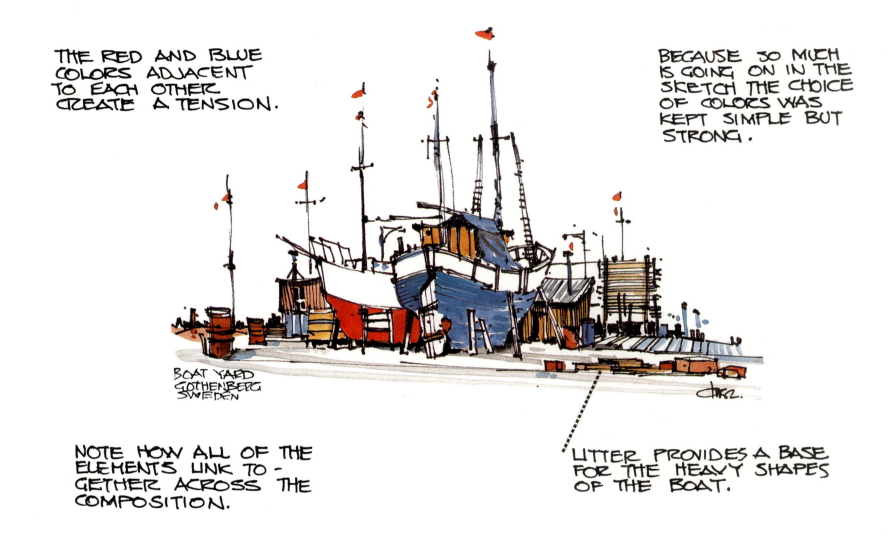

BOAT YARD
GOTHENBERG
SWEDEN

NOTE HOW ALL OF THE
ELEMENTS LINK TO -
GETHER ACROSS THE
COMPOSITION.

LITTER PROVIDES A BASE
FOR THE HEAVY SHAPES
OF THE BOAT.

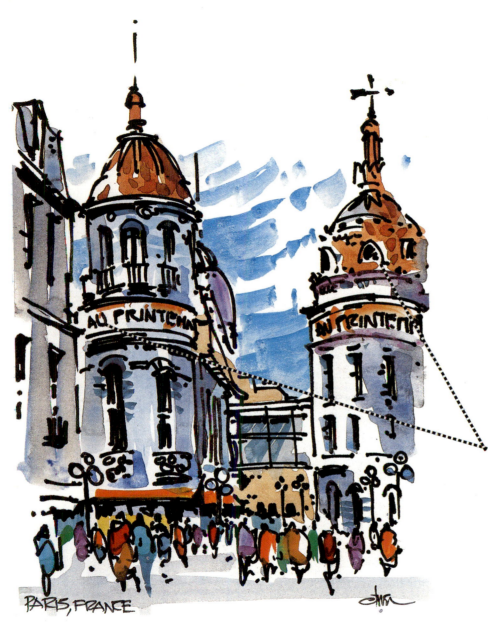

PARIS, FRANCE

THIS IS A VERY QUICK
SKETCH WITH AN
ECONOMY OF LINE.
THIS IS DUE TO A LARGE
TIP ON THE PEN RENDER-
ING A SMALL SKETCH.

DUE TO THE SIMPLE
QUALITY OF THE LINE
SKETCH, THE WATER-
COLOR WAS APPLIED
IN A SIMILAR LOOSE
AND BOLD FASHION.

NOTE THE IMPORTANCE
OF LEAVING WHITES
AND THE INTRODUCTION OF
SOLID BLACKS.

PEN AND BRUSH STROKES
ESTABLISH THE DIRECTION
OF THE GROUND AND MOUNT-
AIN PLANES.

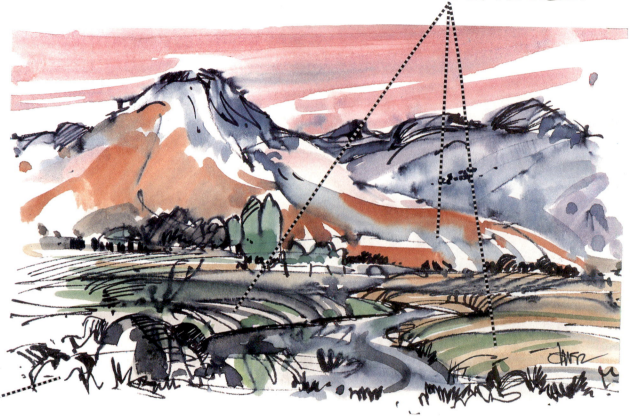

THE WEDGE SHAPED POINT
OF THE CALIGRAPHIC PEN
PROVIDES A VARIETY OF
LINE WEIGHTS.

INK DISSOLVES IN THE WATER-
COLOR MEDIUM PROVIDING A
UNIQUE TEXTURE BUT MAKES
IT DIFFICULT TO KEEP THE SKETCH
FRESH AND SPONTANEOUS.

SMALL BARREL MARKER -WEDGE TIP - BRISTOL BOARD

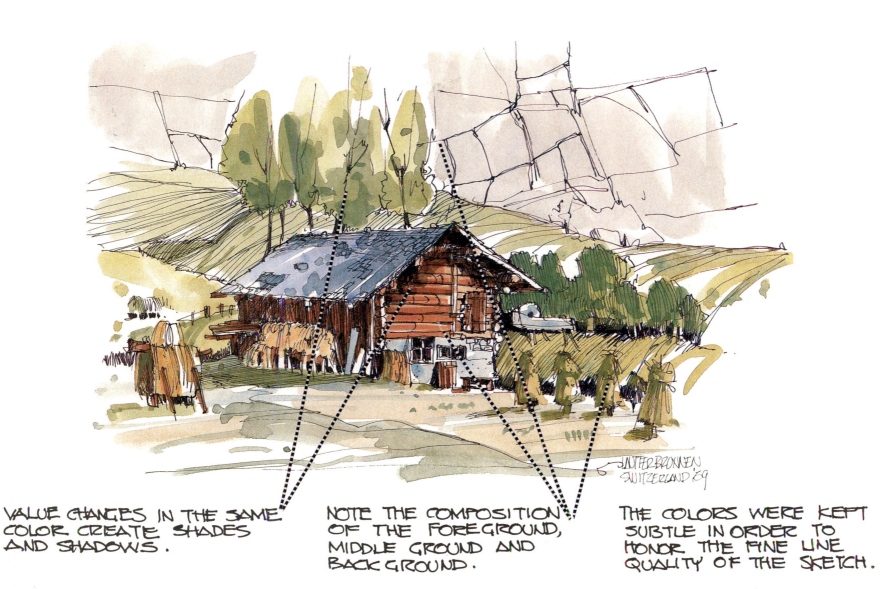

VALUE CHANGES IN THE SAME
COLOR CREATE SHADES
AND SHADOWS.

NOTE THE COMPOSITION
OF THE FOREGROUND,
MIDDLE GROUND AND
BACKGROUND.

THE COLORS WERE KEPT
SUBTLE IN ORDER TO
HONOR THE FINE LINE
QUALITY OF THE SKETCH.

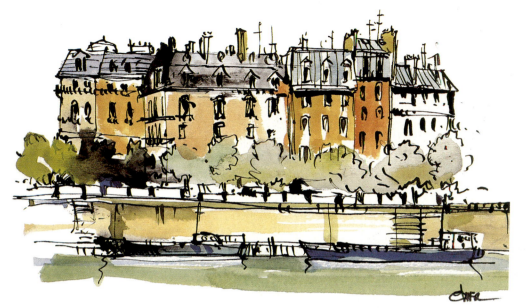

THESE SKETCHES WERE
DONE QUICKLY AND WITH
LITTLE DETAIL ALLOWING
THE COLOR TO TIE THE
COMPOSITION TOGETHER.

THE CHARM OF THE
SKETCHES IS THE
RESULT OF THE PEN
STROKES.

ALONG THE SEINE IN PARIS

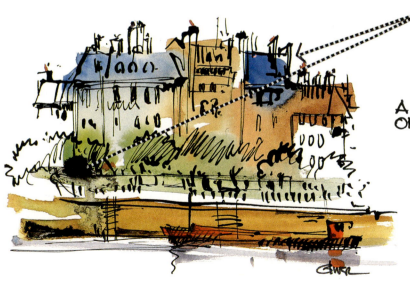

DONT WORRY
ABOUT ACCIDENTS.
THEY ARE ONLY
SKETCHES.

A LITTLE TOUCH
OF MARKER HERE.

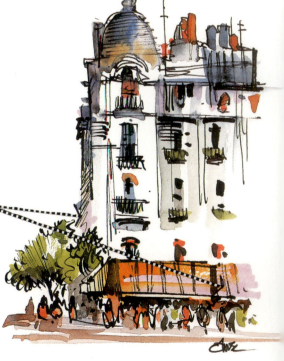

QUILL WRITING PEN — FINE FLEXIBLE POINT — MARKER PAPER

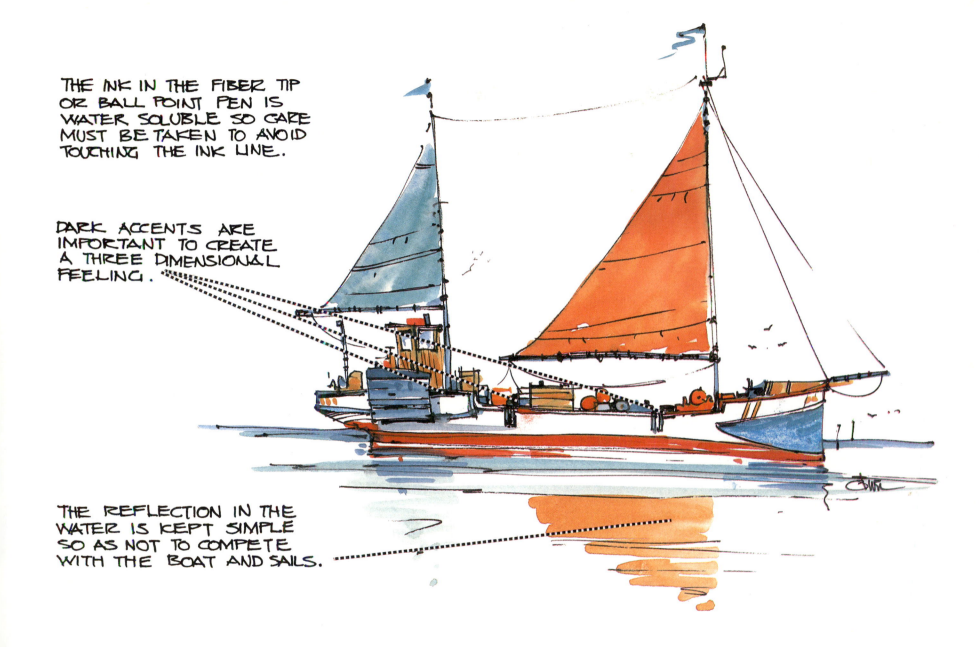

THE INK IN THE FIBER TIP
OR BALL POINT PEN IS
WATER SOLUBLE SO CARE
MUST BE TAKEN TO AVOID
TOUCHING THE INK LINE.

DARK ACCENTS ARE
IMPORTANT TO CREATE
A THREE DIMENSIONAL
FEELING.

THE REFLECTION IN THE
WATER IS KEPT SIMPLE
SO AS NOT TO COMPETE
WITH THE BOAT AND SAILS.

SMALL BARREL PEN — NYLON TIP — MARKER PAPER 57

THE BLACK ACCENTS ARE NECESSARY
TO PROVIDE CONTRAST AND EXCITEMENT.
THEY PROVIDE THE EXCLAMATION POINT

THE VARIETY IN
THE LINE QUALITY
IS DUE TO THE
FLEXIBLE NIB OF
THE PEN.

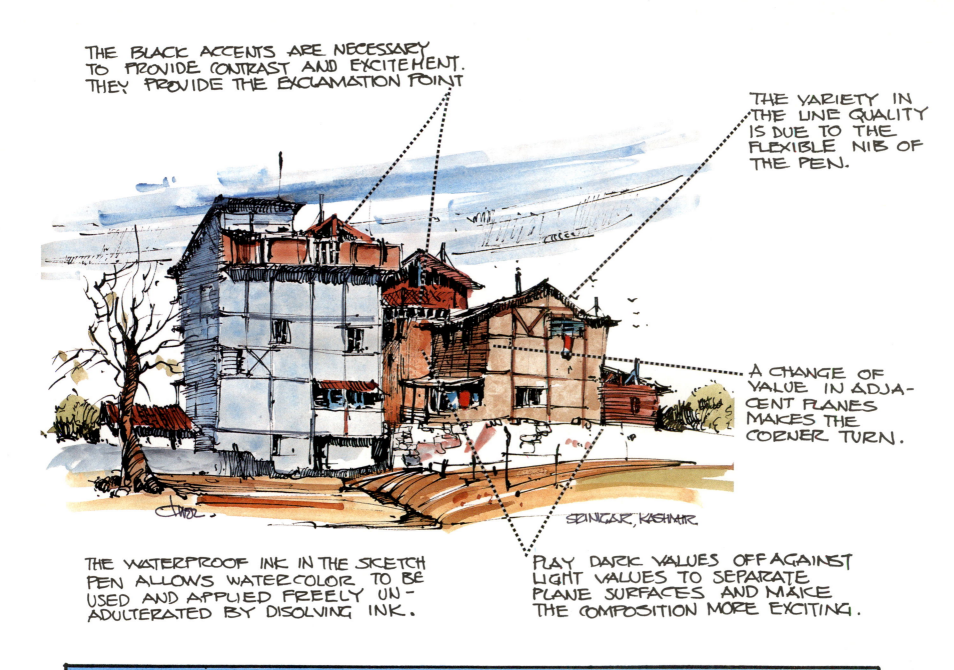

SRINAGAR, KASHMIR

A CHANGE OF
VALUE IN ADJA-
CENT PLANES
MAKES THE
CORNER TURN.

THE WATERPROOF INK IN THE SKETCH
PEN ALLOWS WATERCOLOR TO BE
USED AND APPLIED FREELY UN-
ADULTERATED BY DISOLVING INK.

PLAY DARK VALUES OFF AGAINST
LIGHT VALUES TO SEPARATE
PLANE SURFACES AND MAKE
THE COMPOSITION MORE EXCITING.

MEDIUM BARREL SKETCH PEN - FLEXIBLE POINT - SKETCH PAPER

THIS WAS A VERY QUICK
SKETCH WHICH WAS MEANT
ONLY TO CATCH THE MOOD
OF THE OLD DILAPITATED
BUILDING.

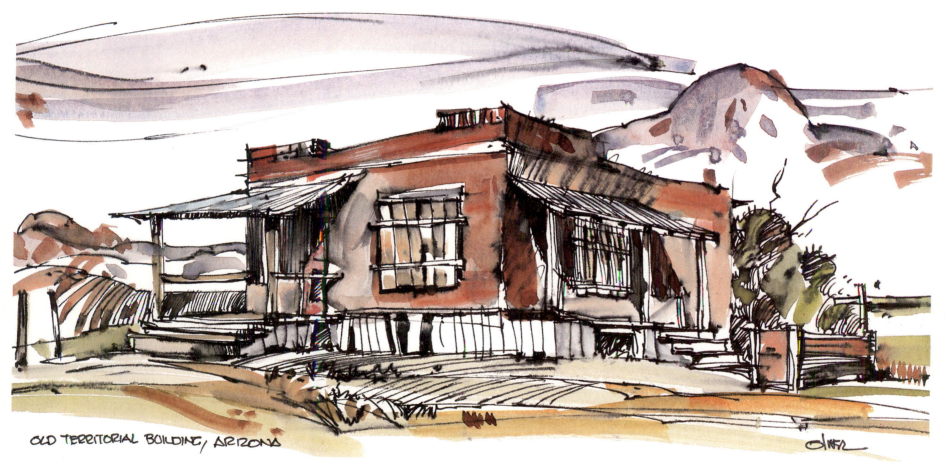

OLD TERRITORIAL BUILDING, ARIZONA

THE SOLUBLE INK IN THE PEN IS USED
TO AN ADVANTAGE IN THIS SKETCH
TO GIVE A PATINA TO THE COLORED
SURFACES.

THE COLORS WERE KEPT
SOMBER AND LOW KEY
IN ORDER TO ENHANCE THE
MOOD OF THE SKETCH.

WRITING FOUNTAIN PEN - MEDIUM RIGID POINT - WATERCOLOR PAPER | 59

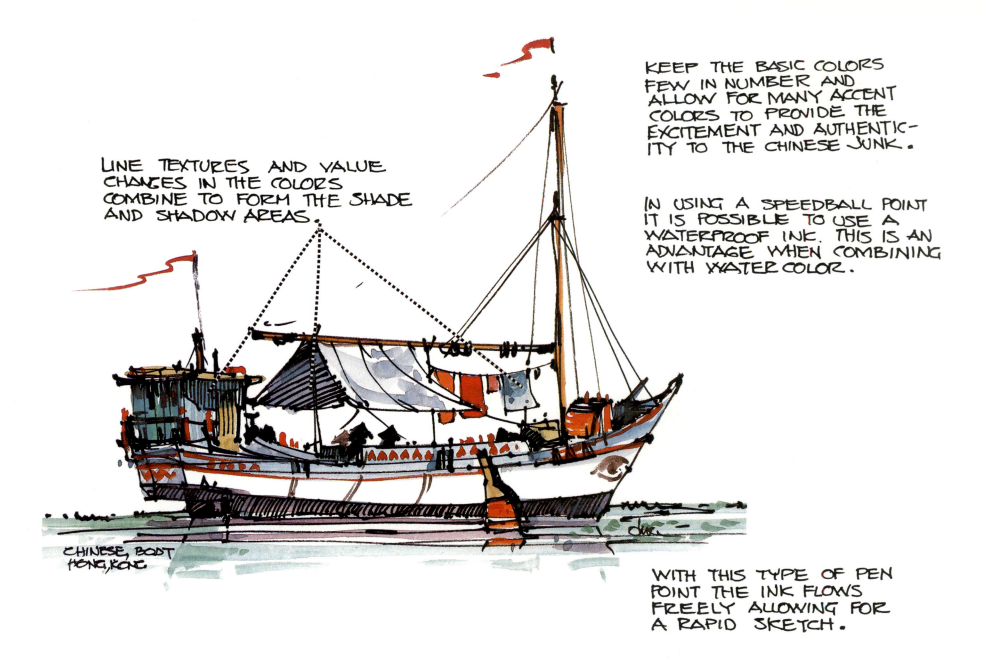

KEEP THE BASIC COLORS
FEW IN NUMBER AND
ALLOW FOR MANY ACCENT
COLORS TO PROVIDE THE
EXCITEMENT AND AUTHENTIC-
ITY TO THE CHINESE JUNK.

IN USING A SPEEDBALL POINT
IT IS POSSIBLE TO USE A
WATERPROOF INK. THIS IS AN
ADVANTAGE WHEN COMBINING
WITH WATER COLOR.

LINE TEXTURES AND VALUE
CHANGES IN THE COLORS
COMBINE TO FORM THE SHADE
AND SHADOW AREAS.

CHINESE BOAT
HONG KONG

WITH THIS TYPE OF PEN
POINT THE INK FLOWS
FREELY ALLOWING FOR
A RAPID SKETCH.

SPEEDBALL PEN — SMALL POINT B-6 — HEAVY SKETCH PAPER

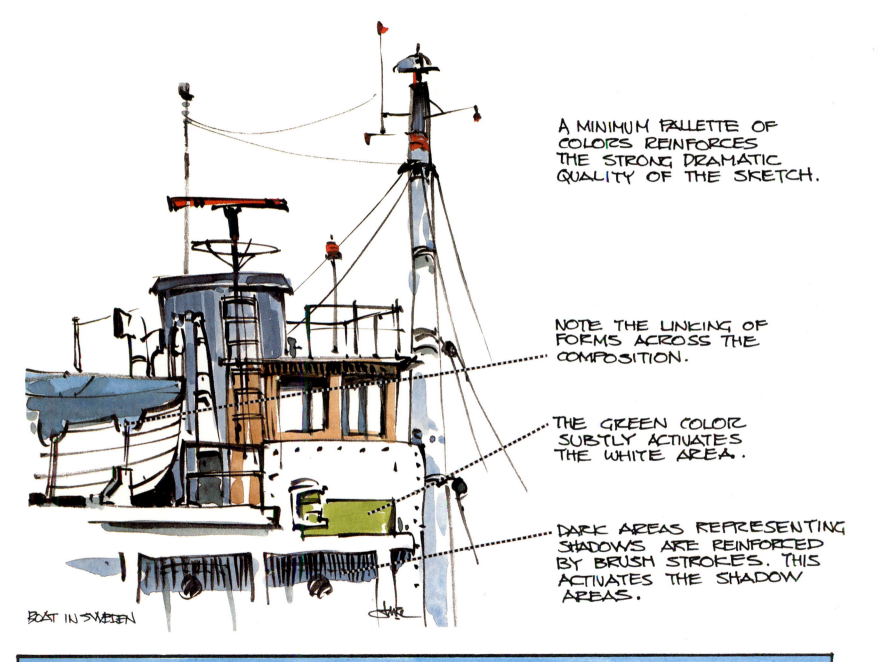

A MINIMUM PALLETTE OF COLORS REINFORCES THE STRONG DRAMATIC QUALITY OF THE SKETCH.

NOTE THE LINKING OF FORMS ACROSS THE COMPOSITION.

THE GREEN COLOR SUBTLY ACTIVATES THE WHITE AREA.

DARK AREAS REPRESENTING SHADOWS ARE REINFORCED BY BRUSH STROKES. THIS ACTIVATES THE SHADOW AREAS.

BOAT IN SWEDEN

WATERCOLOR PAINT BRUSH - SMALL HAIR #1 - HEAVY SKETCH PAPER | 61

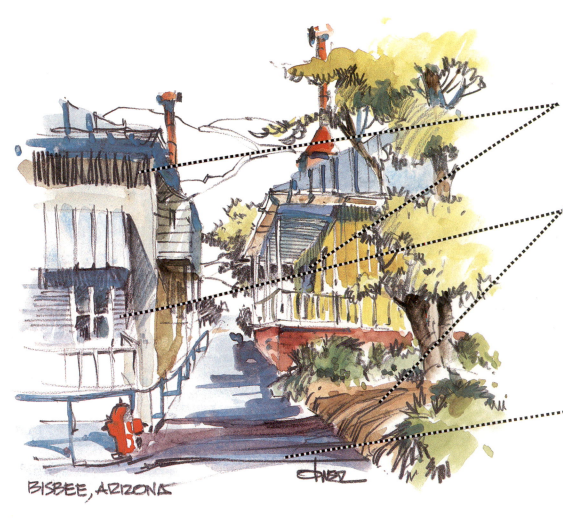

NOTICE THE IMPORTANCE OF SHADOWS.

THE APPLICATION OF THE WATERCOLOR TENDS TO DISGUISE SOME OF THE PENCIL SKETCH. IT MAY BE NECESSARY TO ADD LINES LATER TO BRING BACK THE QUALITY OF THE PENCIL LINE.

THE DARK SHADOW IN THE FOREGROUND PROVIDES A FRAME AND STOPS THE ACTION OF THE ROAD.

BISBEE, ARIZONA

DRAWING PENCIL # 3B - SKETCH PAPER

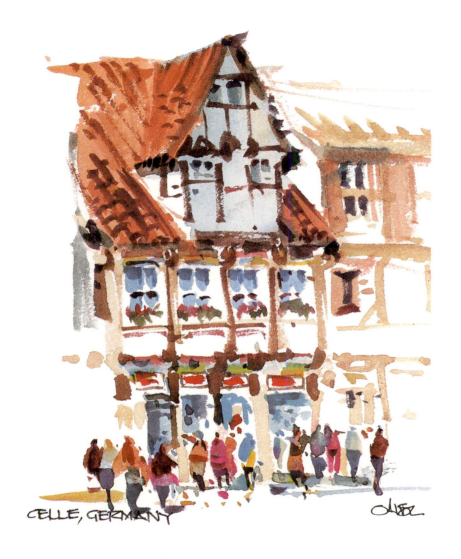

CELLE, GERMANY

IN A WATERCOLOR SKETCH OF THIS TYPE IT IS ONLY POSSIBLE TO CAPTURE THE ESSENCE OF THE SCENE. IN ORDER TO DO THIS IT IS BEST TO RELY ON THE FORM AND COLOR WITH THE DETAIL PLAYING A MINOR ROLE.

IN A WATERCOLOR SKETCH OF THIS TYPE ONE CAN ONLY EXPECT TO CAPTURE THE FEELING

CONTRASTING VALUES OF THE COLORS PROVIDE ALL THE DIMENSION. INK LINES ARE MISSING. THESE NORMALLY DEFINE THE FORMS.

OPAQUE WATER COLOR

OPAQUE WATERCOLOR IS EXACTLY AS THE NAME SUGGESTS. IT IS NOT TRANSPARENT AND EACH COLOR THAT IS APPLIED OVER THE FIRST MASKS IT OUT. IT IS UNDERSTANDABLE, THEN, THAT THE RESULTS OF ITS USE WITH THE SKETCH WILL BE QUITE UNLIKE THAT OF TRANSPARENT WATERCOLOR. THIS DOES NOT DEPRECIATE ITS EFFECTIVENESS AS A SUPPORT MEDIUM TO THE INK LINE DRAWING. BECAUSE OF ITS MASK-ING OUT FEATURE, OPAQUE WATER-COLOR MUST BE USED CAREFULLY SO AS NOT TO OBLITERATE THE LINE DRAWING. AS DEMONSTRATED IN THE FOLLOWING PAGES THE SUCCESS OF THE OPAQUE WATERCOLOR IS ACHIEVED ON A TINTED SURFACE.

MUCH LIKE TRANSPARENT WATER-COLORS, ANY VARIETY OF OPAQUE COLOR CAN BE MIXED AND IS ONLY LIMITED BY THE VARIETY OF COLORS USED IN THE MIXING PROCESS. WHITE IS AN IMPORTANT ADDITION TO THE COLOR PALLETTE BECAUSE IT IS USED EXTENSIVELY TO LIGHTEN THE VALUE OF THE COLORS. UNLIKE THE TRANS-PARENT WATERCOLORS TO WHICH MOISTURE IS ADDED TO REVIVE THEM, FRESH PIGMENTS FROM THE OPAQUE

WATERCOLOR TUBES ARE USED. IT IS EASIER AND QUICKER TO GET RICH MIXES FROM THE VARIOUS PIGMENTS BY USING THEM FRESH FROM THE TUBES.

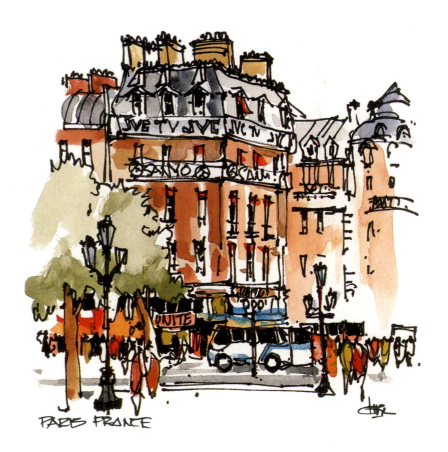

PARIS FRANCE

64

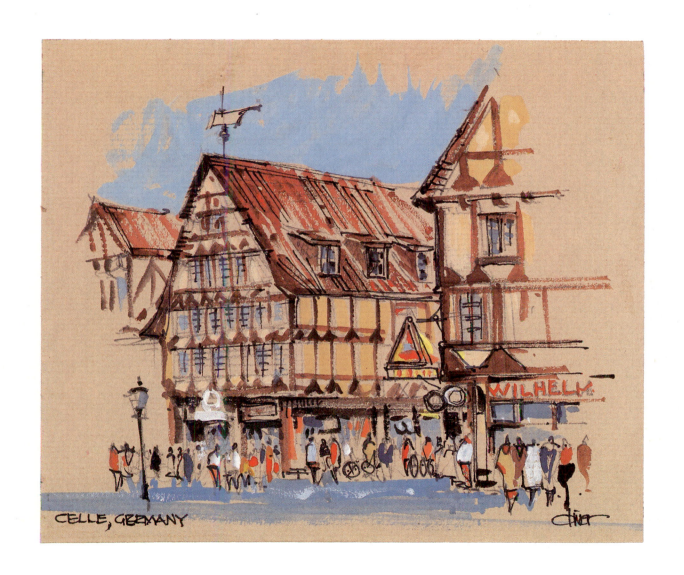

CELLE, GERMANY

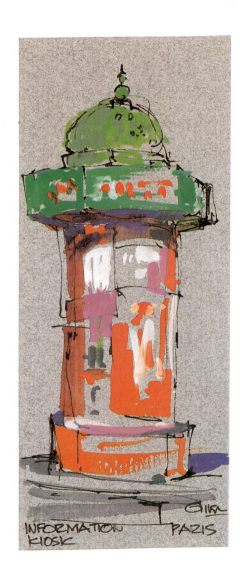

INFORMATION
KIOSK

PARIS

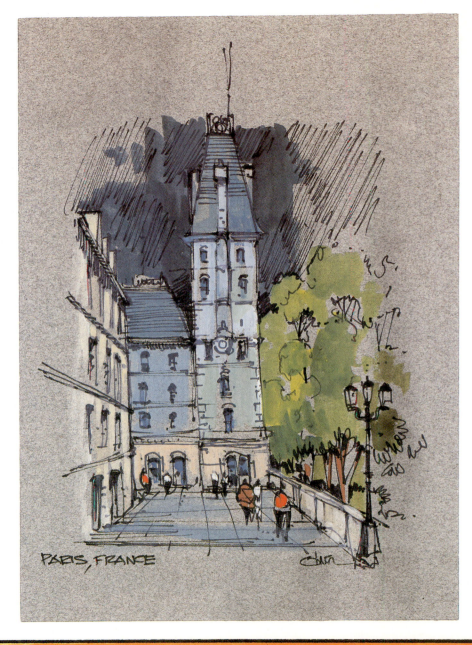

PARIS, FRANCE

SMALL BARREL MARKER - FINE TIP - TINTED CHARCOAL PAPER

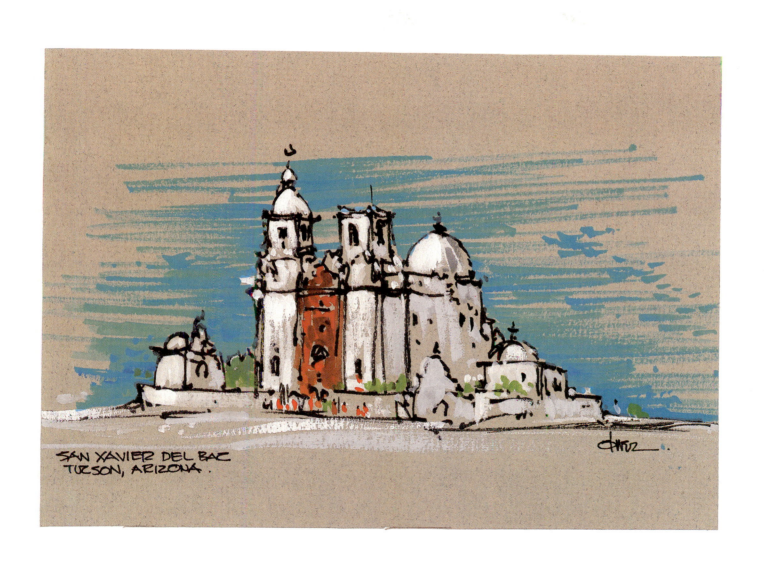

SAN XAVIER DEL BAC
TUCSON, ARIZONA.

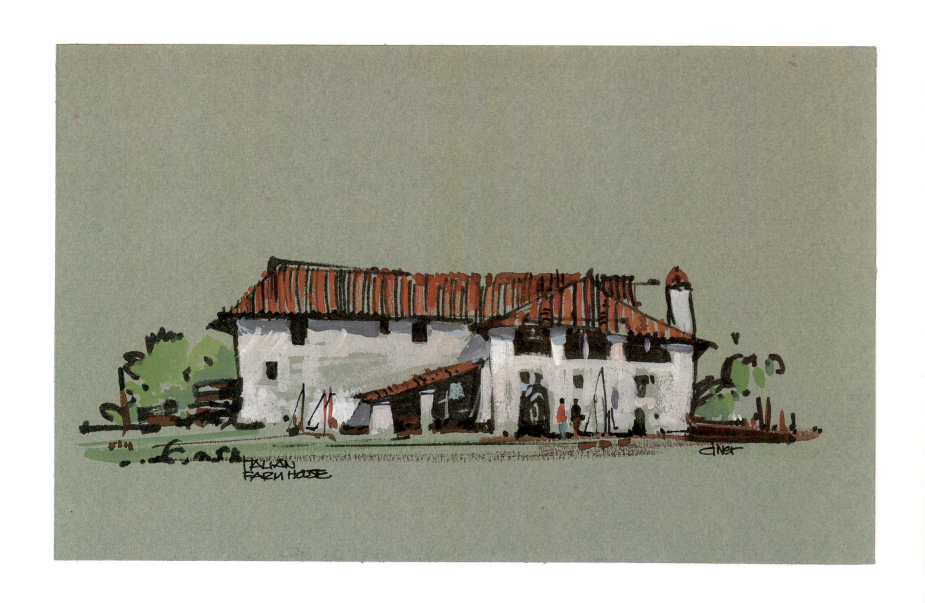

ITALIAN
FARM HOUSE

SMALL BARREL MARKER - LARGE TIP - TINTED CHARCOAL PAPER

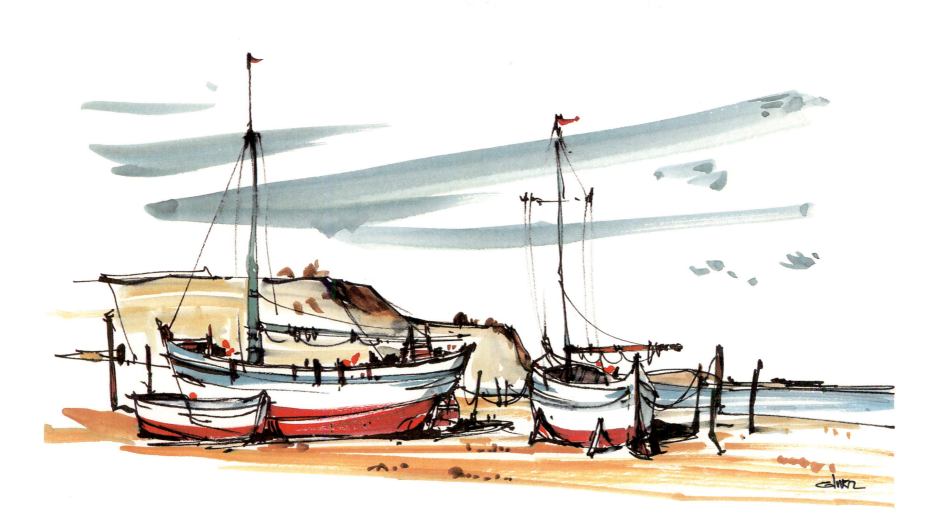

SMALL BARREL MARKER - WEDGE TIP - MARKER PAPER 69

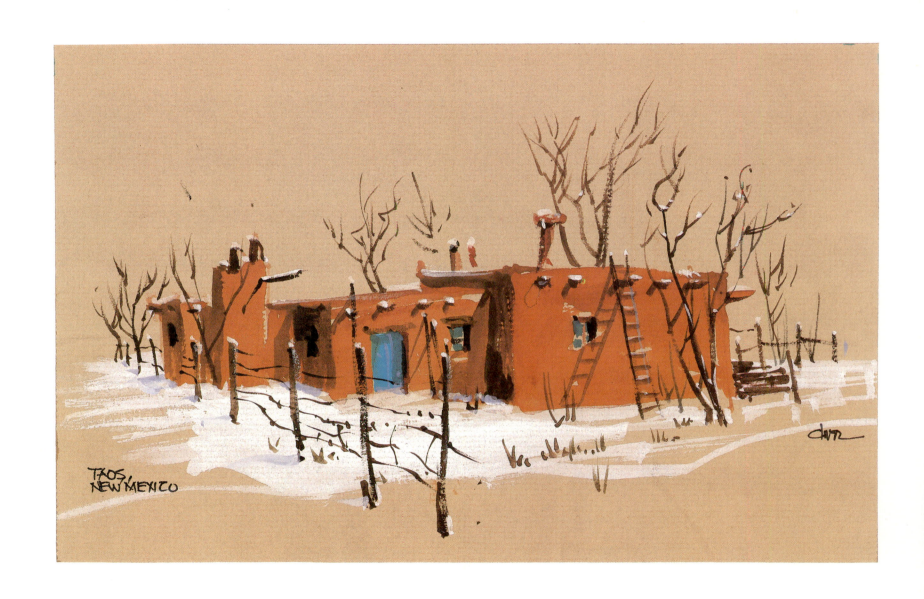

TAOS,
NEW MEXICO

WATERCOLOR BRUSH - SMALL AND MEDIUM #1 · #6 - TINTED PAPER

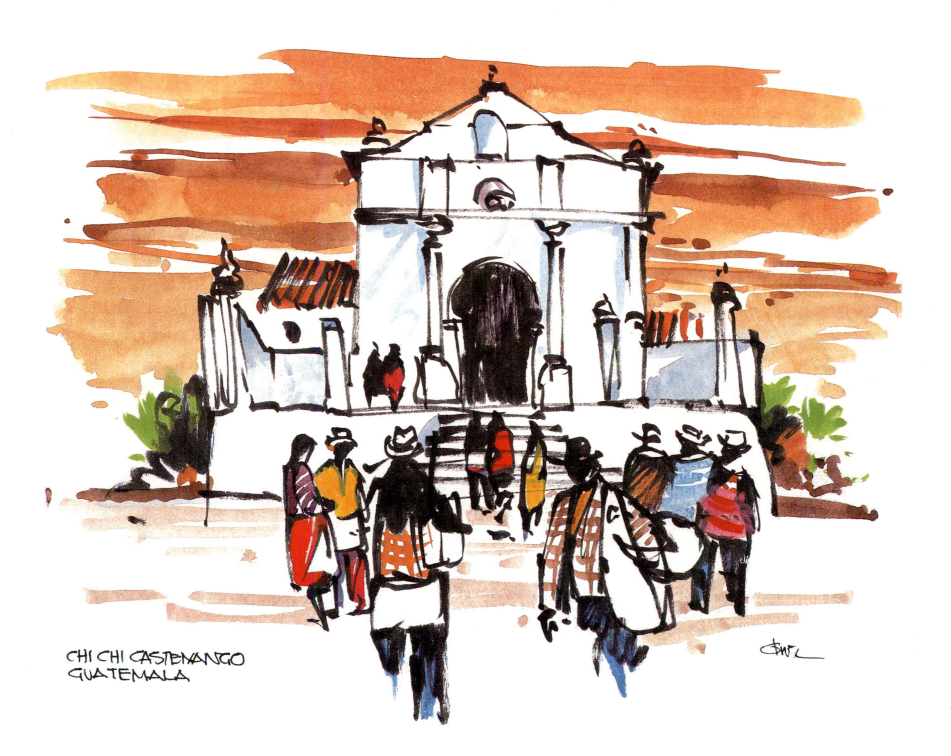

CHI CHI CASTENANGO
GUATEMALA

71

5 MARKERS

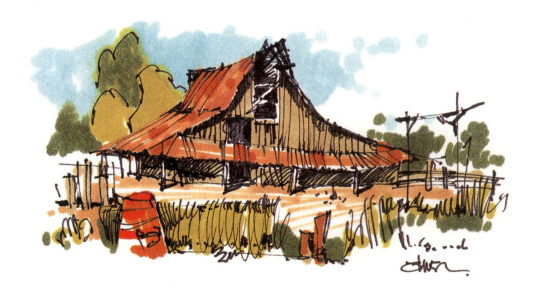

A MARKER IS A COLORED DRAW-ING INSTRUMENT MADE UP OF A TIP CONSISTING OF A FELT OR FIBEROUS SUBSTANCE FED BY A RESERVOIR OF DYE. THESE COME IN VARIOUS SIZES, SHAPES, TIPS AND COLORS AND BEAR MANY DIFFERENT TRADE MARKS. THESE PENS WILL BE REFERRED TO AS MARKERS SINCE THEY ALL PERFORM IN MANY SIMILAR WAYS. THE COLOR MEDIUM IS EITHER OIL BASED OR WATER SOLUBLE. THE OIL BASED COLORS ARE SOMEWHAT LIGHT FUGITIVE AND THEREFORE SUBJECT TO FADING IN NATURAL LIGHT. THERE ARE SPRAY SCREENS THAT ARE SAID TO HAVE SCREEN-ING POWERS AGAINST FADING. THIS WHOLE INDUSTRY IS SO NEW THAT I DON'T THINK THE RESULTS OF SCREENING AGAINST ULTRAVIOLET RAYS HAS BEEN PROVEN. HOWEVER, SINCE THE SKETCH IS AT STAKE, PER-MANENCY IS NOT A MAJOR FACTOR.

THERE IS A WIDE VARIETY OF POINT TYPES AND SHAPES. IT IS SUGGESTED THAT THEY BE EXPERIMENTED WITH AS THE DEMONSTRATIONS IN THIS BOOK SUGGEST. ONE IMPORTANT WARN-ING IS THAT THE PENS DO DRY OUT IF LEFT EXPOSED SO KEEP THEM CAPPED SECURELY WHEN NOT IN USE.

THE USE OF THE MARKER IS NOT DIFFICULT TO LEARN AND TAKES LITTLE OR NO EXPERIENCE. IT IS A VERY GOOD WAY TO GET IN TO THE APPRECIATION OF COLOR WITH-OUT ALL OF THE DIFFICULTIES OF MIXING COLORS TO ACHIEVE OTHER COLORS. THERE IS AN UNLIMITED VARIETY OF COLORS. WHEN IN THE FIELD A SMALL SELECTION OF MARK-ERS SHOULD BE MAINTAINED FROM THE LARGER SUPPLY IN THE STUDIO BECAUSE THEY CAN BE BULKY.

THE BIGGEST DIFFERENCE BE-TWEEN WATERCOLORS AND MARK-ERS IS IN THE PORTABILITY OF THE MANY VARIETIES OF COLORS. WITH A SMALL WATERCOLOR KIT THERE ARE TWELVE COLORS THAT CAN BE INTERMIXED TO OBTAIN EVEN MORE COLORS. COMPARE THIS WITH ONE MARKER FOR EACH COLOR. THE APPLICATION OF WATERCOLOR AND MARKERS IS DIFFERENT BUT THE END RESULTS ARE EQUALLY AS EFFECTIVE.

THERE ARE PAPERS ON THE MAR-KET ESPECIALLY DESIGNED FOR USE WITH MARKERS SO THAT THERE WILL BE NO BLEEDING ON THE SUR-FACE OR THROUGH THE PAPER. THIS DOES NOT PRECLUDE THIER USE ON OTHER PAPERS.

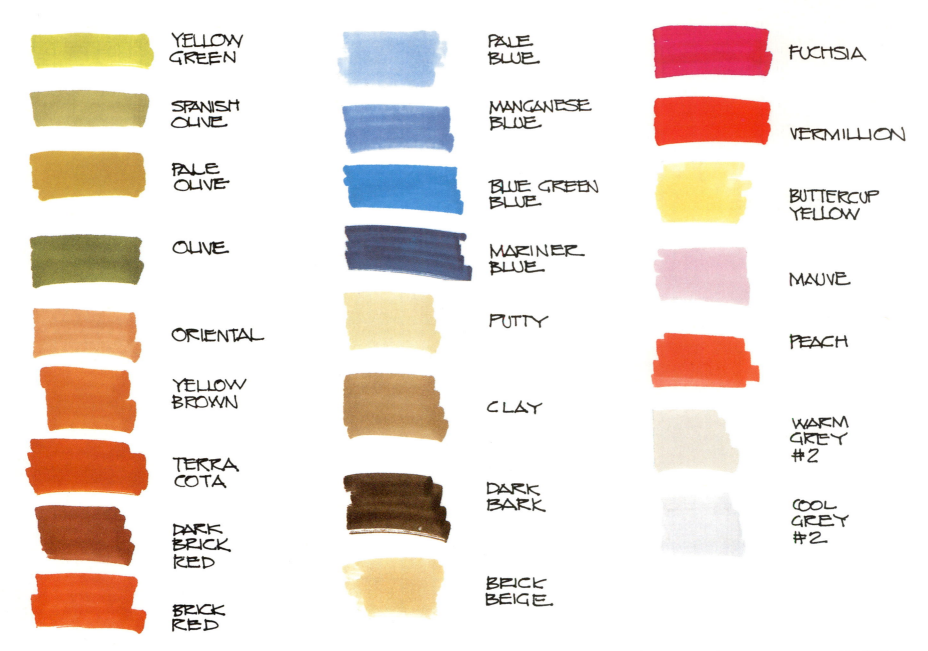

YELLOW GREEN

SPANISH OLIVE

PALE OLIVE

OLIVE

ORIENTAL

YELLOW BROWN

TERRA COTA

DARK BRICK RED

BRICK RED

PALE BLUE

MANGANESE BLUE

BLUE GREEN BLUE

MARINER BLUE

PUTTY

CLAY

DARK BARK

BRICK BEIGE.

FUCHSIA

VERMILLION

BUTTERCUP YELLOW

MAUVE

PEACH

WARM GREY #2

COOL GREY #2

74 THESE COLORS REPRESENT THE ONES USED IN THE SKETCHES IN THIS BOOK. THERE ARE A GREAT MANY MORE. THE SELECTION IS ENTIRELY A PERSONAL ONE.

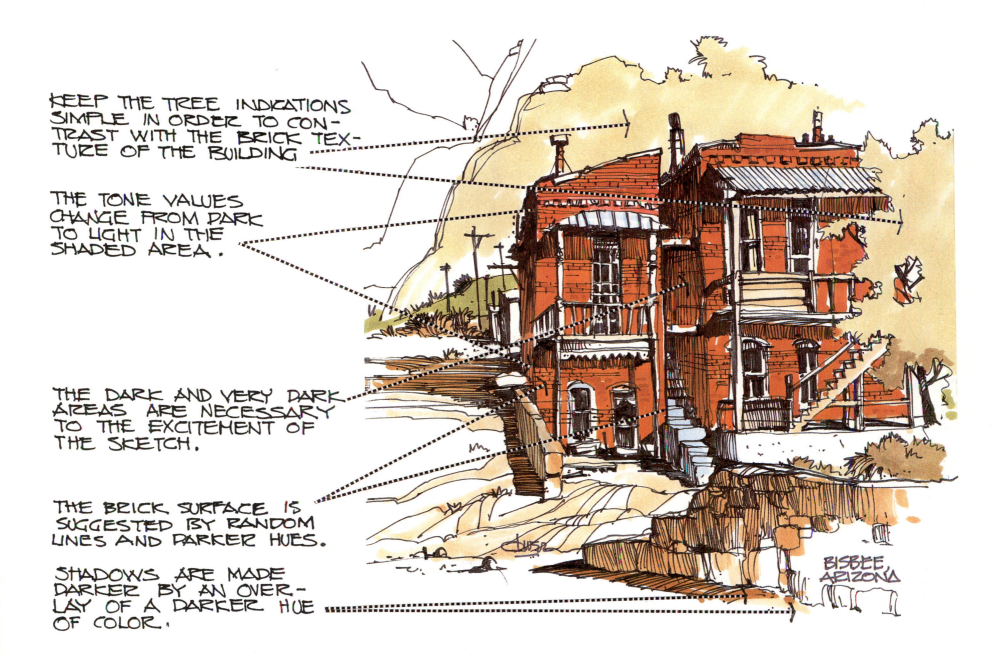

KEEP THE TREE INDICATIONS SIMPLE IN ORDER TO CONTRAST WITH THE BRICK TEXTURE OF THE BUILDING

THE TONE VALUES CHANGE FROM DARK TO LIGHT IN THE SHADED AREA.

THE DARK AND VERY DARK AREAS ARE NECESSARY TO THE EXCITEMENT OF THE SKETCH.

THE BRICK SURFACE IS SUGGESTED BY RANDOM LINES AND DARKER HUES.

SHADOWS ARE MADE DARKER BY AN OVERLAY OF A DARKER HUE OF COLOR.

BISBEE ARIZONA

LARGE BARREL MARKER - ULTRA FINE POINT - TYPING PAPER.

75

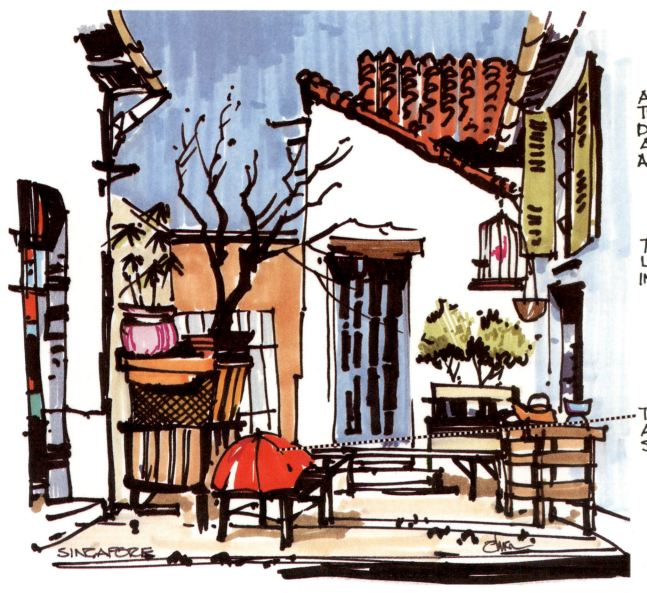

SINGAPORE

ACCENT COLORS THROUGHOUT
THE SKETCH PROVIDE THE
DELIGHT AND THE BLUE
AGAINST THE WHITE PROVIDES
A FRESH QUALITY.

THE BLUE AND RED COMP-
LIMENTARY COLORS RE-
INFORCE EACH OTHER.

THE RED UMBRELLA SERVES
AS A FOCAL POINT IN THE
SKETCH.

OBSERVE HOW IMPORTANT
THE BLACK AREAS ARE TO
THE WHOLE EFFECT.

76 LARGE BARREL MARKER - MEDIUM POINT - MARKER PAPER.

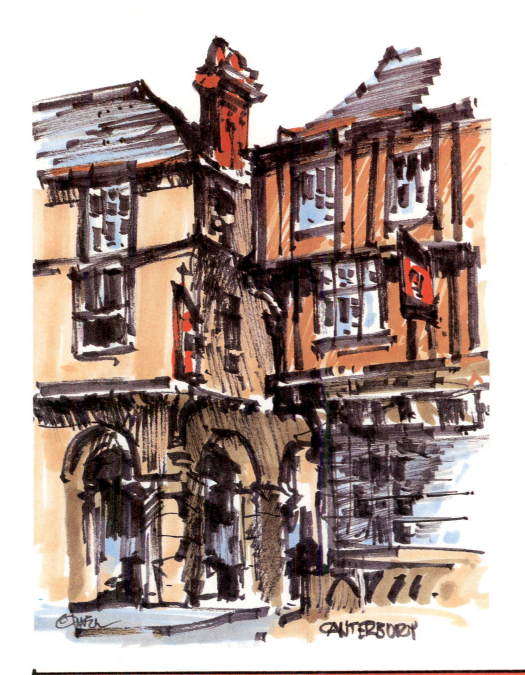

CANTERBURY

THE BROAD EDGE OF THE PEN
TIP ALLOWS THE TIMBERS AND
ROOF SLATES TO BE APPLIED
QUICKLY WITH FEW STROKES.
THIS ALLOWS THE SKETCH TO BE
STRONG AND SPONTANEOUS.

TWO VALUES OF THE SAME
COLOR PROVIDE A PATINA
OR TEXTURE TO THE SURFACE.

THE DETAIL OF THE WINDOWS
IS ONLY SUGGESTED. THE
VIEWER FILLS IN THE BLANKS.

THE BLUE AND RED COLORS
COMPLIMENT EACH OTHER AND
STAND OUT IN THE NEUTRAL
MATRIX OF BEIGE.

LARGE BARREL MARKER - BROAD TIP - ABSORBANT DRAWING PAPER 77

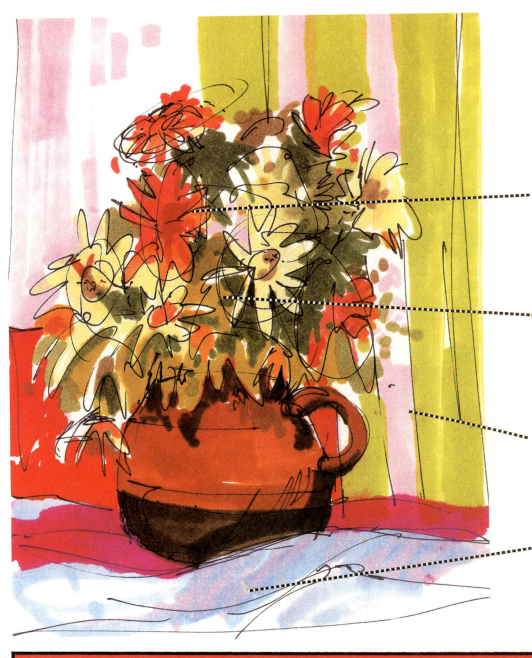

THIS SKETCH WITH A BALL POINT PEN WOULD ALSO HAVE THE SAME APPEARANCE IF DONE WITH A NYLON TIP PEN.

THE FORMS AND SHAPES ARE ACHIEVED MORE THROUGH THE COLORED MARKERS THAN THE PEN LINE.

A CHANGE IN VALUE WITHIN THE COLOR AREAS IS AS IMPORTANT AS A CHANGE OF COLORS.

THE BACKGROUND IS MADE STATIC IN CONTRAST TO THE DYNAMIC QUALITY IN THE FLOWERS.

COLORS ARE OVERLAID IN THE FABRIC ON THE TABLE.

78 SMALL BARREL MARKER - FINE TIP - CHEAP TYPING PAPER

WHITES LEFT IN PICTURE
PROVIDE NEEDED AC-
CENTS FOR INTEREST.

KEEP ALL COLORS SIMILAR IN
HUE AND VALUE. THIS WILL
ALLOW THE BRIGHT COLORS TO
PROVIDE IMPACT AND A CENTER
OF INTEREST.

NOTE SMALL DETAIL
SUGGESTIONS

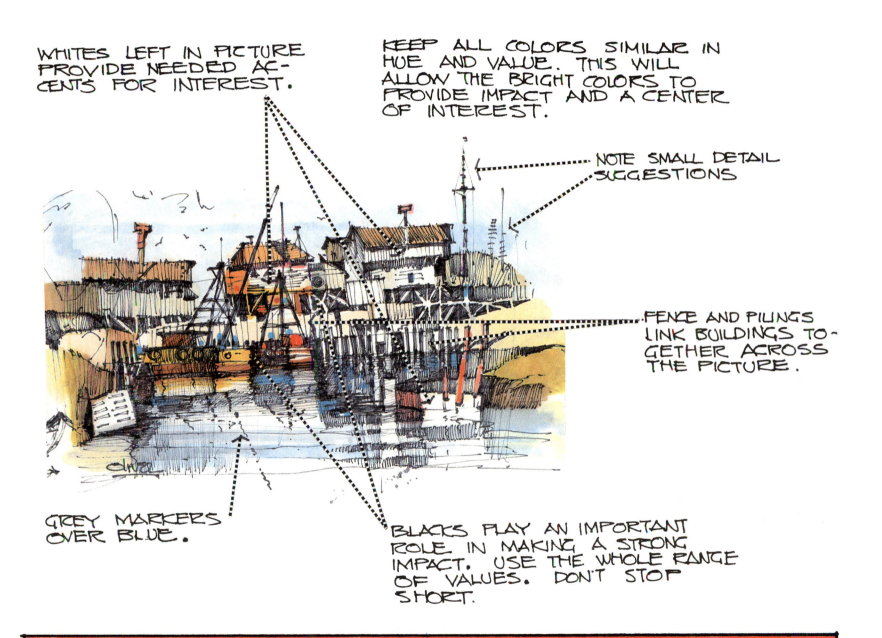

FENCE AND PILINGS
LINK BUILDINGS TO-
GETHER ACROSS
THE PICTURE.

GREY MARKERS
OVER BLUE.

BLACKS PLAY AN IMPORTANT
ROLE IN MAKING A STRONG
IMPACT. USE THE WHOLE RANGE
OF VALUES. DON'T STOP
SHORT.

SMALL BARREL MARKER - ULTRA FINE TIP - DITTO COPY PAPER.

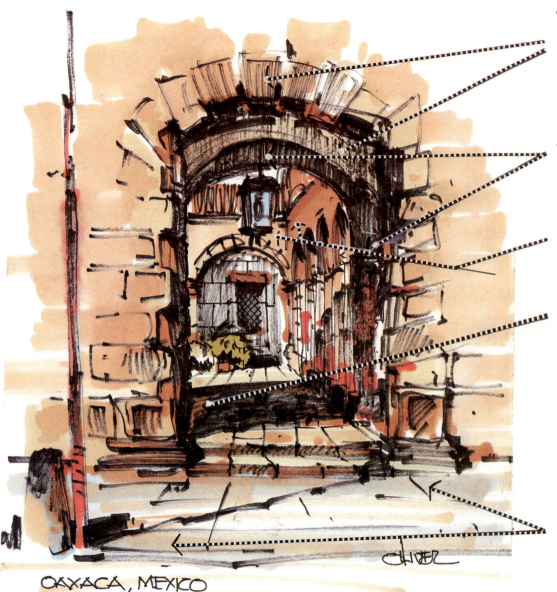

THE FELT PEN WAS GETTING DRY DURING THE MAKING OF THE SKETCH. THIS ACCOUNTS FOR THE GREY STROKES WHICH SOFTEN THE SKETCH AND GIVES IT CHARACTER.

THE DARKS OF THE SHADED AREA HELP TO EMPHASIZE THE LIGHT, SUNNY COURTYARD.

NOTE THE CHANGE IN VALUE OF COLOR EMPHASIZES THE PERPENDICULAR PLANES.

IT IS NECESSARY TO LEAVE LIGHT AREAS ON THE FLOOR AND CEILING ARCHES TO GIVE LIFE AND QUALITY TO THE DARK AREAS.

UNIFYING COLOR WITH STRONG DARKS, SHADOWS AND ACCENTS OF COLOR PROVIDES A FOCAL POINT IN THE SKETCH.

OVERLAY OF GREY MARKER CHANGES COLOR AND TONE OF THE ORIGIONAL BEIGE COLOR.

OAXACA, MEXICO

80 SMALL BARREL MARKER · MEDIUM TIP · ABSORBANT DRAWING PAPER

DETAIL WAS KEPT TO A
MINIMUM IN ORDER TO PRE-
SERVE THE SOFT QUALITY.

THE ABSORBANT SURFACE
CREATES SOFT EDGES TO
THE MARKER STROKES.

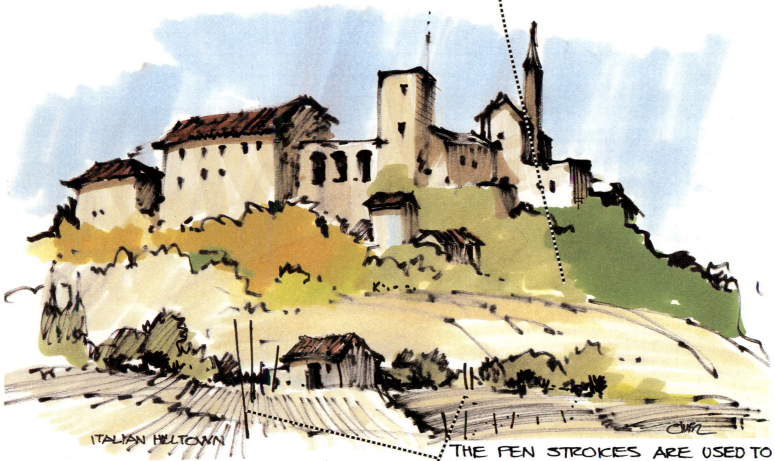

ITALIAN HILLTOWN

THE SKETCH WAS DONE ON
ABSORBANT PAPER PRO-
VIDING AN INTERESTING
SOFT APPEARANCE.

THE PEN STROKES ARE USED TO
DEPICT GROUND FURROWS BUT
THEY ALSO SERVE TO INCREASE
THE HORIZONTAL FEELING OF THE
GROUND PLANES.

SMALL BARREL MARKER - LARGE TIP - SUMI SKETCH PAPER 81

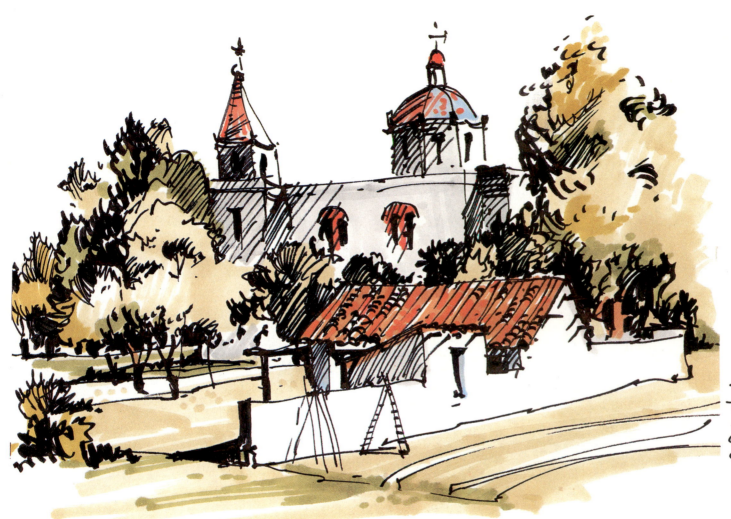

THE CONTRAST BE-
TWEEN THE WHITE
AND GREY WALLS
CREATES A SENSE
OF DISTANCE.

THE CALLIGRAPHIC PEN POINT LENDS
ITSELF PARTICULARLY WELL IN CREATING
LANDSCAPE FORMS SUCH AS TREES
AND BUSHES.

THE VARIETY OF GREEN TONES
IN THE TREES AND GROUND LINKS
THE COMPOSITION TOGETHER.

82 SMALL BARREL MARKER - WEDGE TIP - DRAWING PAPER.

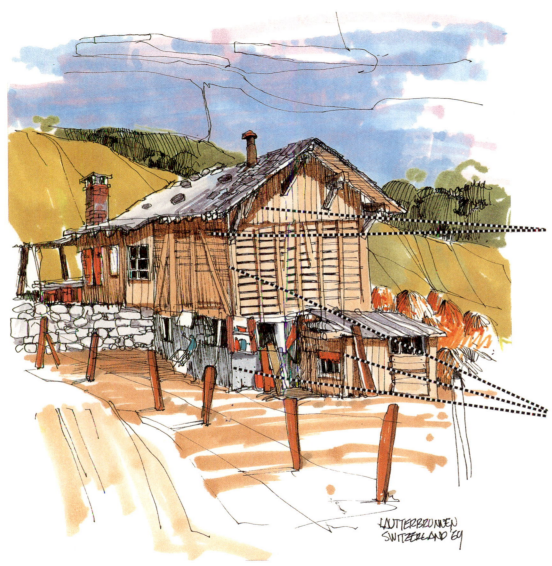

BECAUSE THE LINE QUALITY IS DELICATE, SO ARE THE VALUE CHANGES IN THE COLORS.

SHADOWS ARE ALWAYS DARKER VALUES OF THE SURFACE COLOR.

THE CHANGE IN DIRECTION OF THE WALL SURFACES IS RE-INFORCED BY THE DARKER VALUES OF THE COLOR.

LAUTERBRUNNEN SWITZERLAND '84

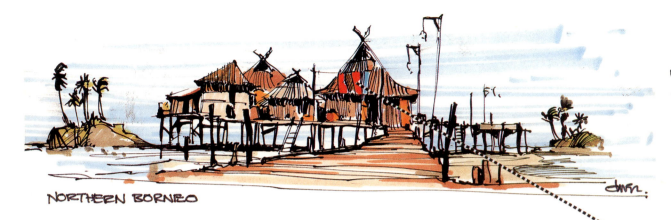

WHEN A QUILL PEN IS
USED FOR SKETCHING
AND TIME IS IMPORTANT,
THE SKETCH MUST BE
NECESSARILY SMALL.

NORTHERN BORNEO

THE JUDICIOUS USE OF
BRIGHT COLORS EN-
LIVENS THE SKETCH.

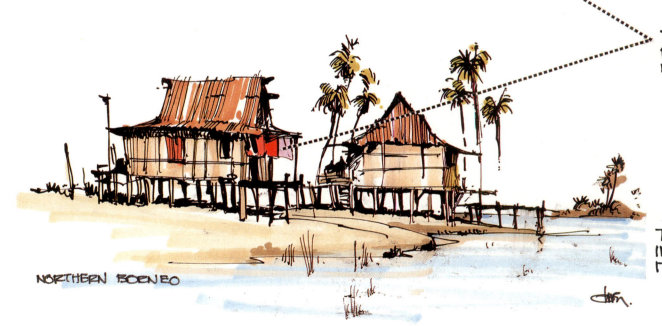

NORTHERN BORNEO

THE TYPE OF ARCHITECTURE
IN THESE SCENES LENDS
ITSELF TO THE QUILL PEN.

QUILL WRITING PEN — FINE FLEXIBLE POINT — BRISTOL BOARD

THE BEIGE COLOR AND THE
WHITES HELP TO UNIFY THE
COMPOSITION.

LIGHT BLUE IS ADDED TO THE
WARM GREY OF THE UMBRELLA
WHICH RELIEVES THE MONOTONY.

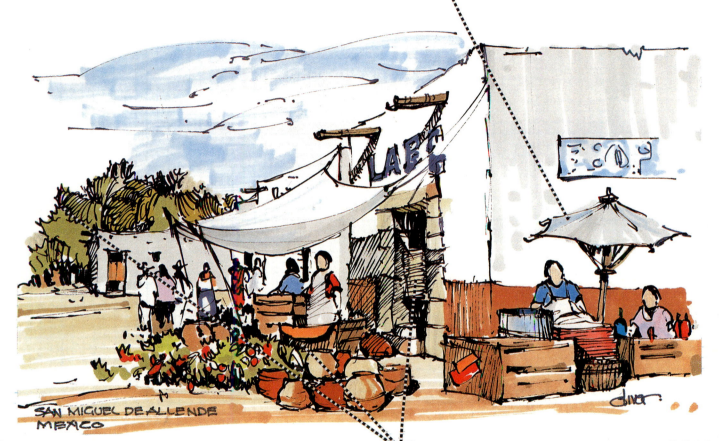

SAN MIGUEL DE ALLENDE
MEXICO

THE SCENE CALLS FOR A LOT OF
COLOR BUT IT WAS LIMITED TO
A MODEST PALLETTE OF COLORS
AVAILABLE.

THE SOFT NATURE OF THE SKETCH
PEN POINT GIVES THE SKETCH AN
INFORMAL LOOK WHICH REINFORC-
ES THE MOOD OF THE SCENE.

MEDIUM BARREL SKETCH PEN - FLEXIBLE POINT - BRISTOL BOARD 85

THE LINKING OF ELEMENTS
THROUGHOUT THE COMPOSITION
SHOULD BE NOTED.

THE DARKS IN THE COMPOSITION
ARE IMPORTANT TO STABILIZE
ALL OF THE ACTIVITY.

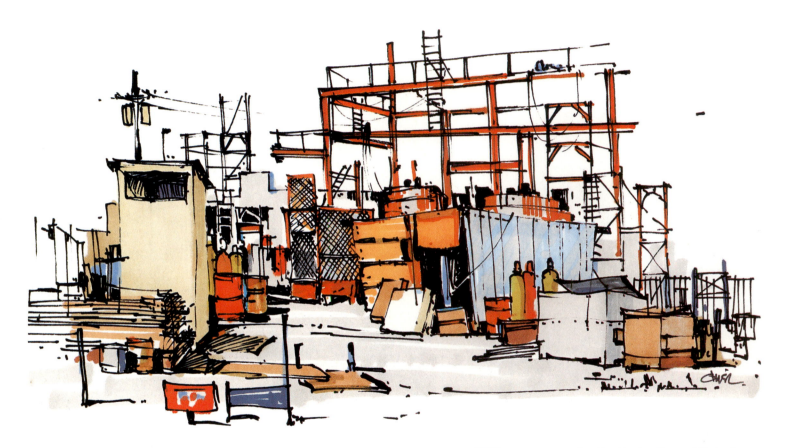

THE MARKER IS COMPATIBLE
WITH FOUNTAIN PEN INK AND
DOES NOT DISSOLVE IT

DEPTH IN THE COMPOSITION
IS ACHIEVED THROUGH
SCALE AND OVERLAPPING
OF ELEMENTS RATHER
THAN THROUGH PERSPECTIVE.

WRITING FOUNTAIN PEN – MEDIUM RIGID TIP – BRISTOL BOARD

THE FREE FLOWING INK
SUPPLY IN THE SPEED
BALL PEN RENDERS A
FREE AND LOOSE SKETCH.
THE WATERPROOF INK
DOES NOT DISOLVE WITH
THE ADDITION OF MARKER
COLOR.

A GREY OVERLAY TENDS
TO DEEPEN COLOR
VALUES.

THE SHADOW AREA UNDER
THE TREE LINE FRAMES
THE ACTIVITY ON THE STREET

THE BUSY STREET SCENE
IS CONTRASTED WITH THE
STRONGER AND SIMPLER
FORMS OF THE BUILDINGS.

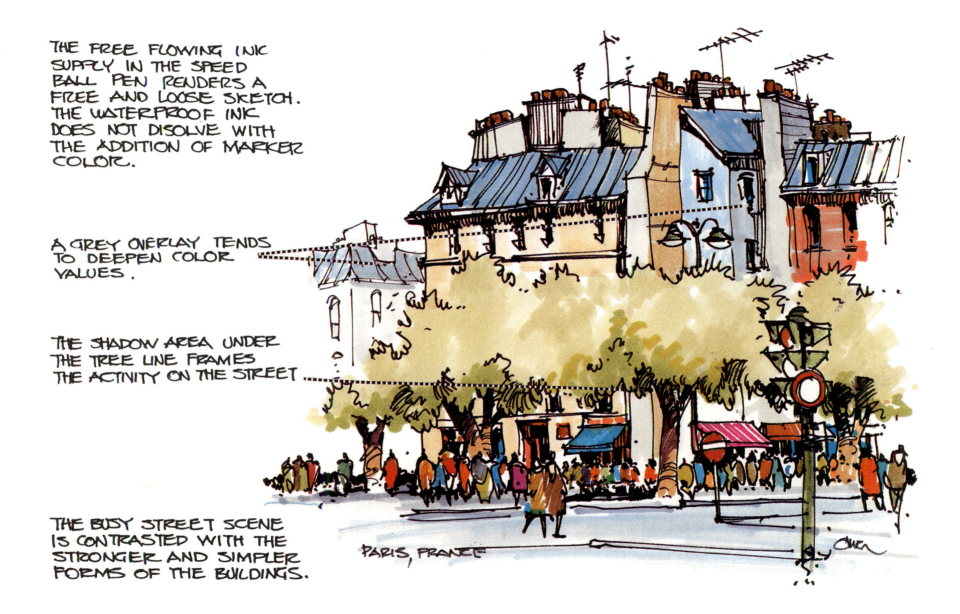

PARIS, FRANCE

SPEED BALL PEN - SMALL POINT B-6 - CHEAP TYPING PAPER

87

THIS IS A QUICK AND BOLD
TECHNIQUE AND HAS A
CHARACTER ONLY ACHIEVED
BY A BRUSH.

THE SKETCH IS PRIMARILY
EXECUTED WITH A BRUSH
WITH A LITTLE HELP OF
A PEN ON THE FENCE.

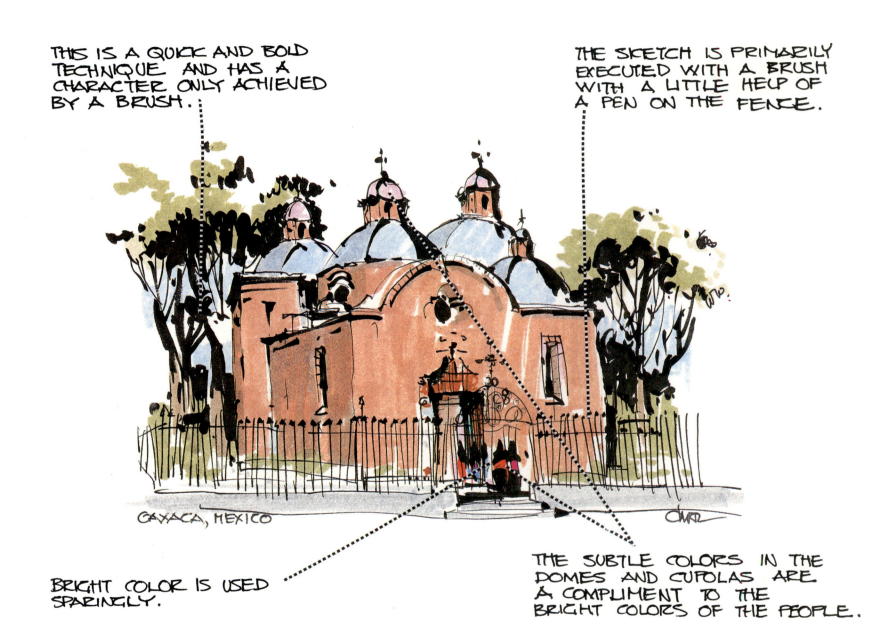

OAXACA, MEXICO

BRIGHT COLOR IS USED
SPARINGLY.

THE SUBTLE COLORS IN THE
DOMES AND CUPOLAS ARE
A COMPLIMENT TO THE
BRIGHT COLORS OF THE PEOPLE.

WATERCOLOR PAINT BRUSH - SMAL HAIR #1 - HEAVY WEIGHT PAPER

A SKETCH OF THIS SCALE
AND COMPLEXITY IS FULL
OF SUGGESTIONS WITHOUT
TOO MUCH ATTENTION TO
DETAIL.

THIS SKETCH WAS DONE
WITH ALL COLORED FELT
PENS AND FELT MARKERS

KATMANDU

THIS SKETCH IS NOT MEANT
TO FOCUS ON A POINT
NECESSARILY BUT TO
GENERATE INTEREST THROUGH-
OUT THE COMPOSITION.

THE ARCHITECTURE IS ACTIVE
AND INTERESTING SO AN EMPHASIS
OF COLOR WAS USED IN THE
PEOPLE TO DRAW ATTENTION
AWAY FROM THE ARCHITECTURE.

6 COLORED PENCILS

SOLUBLE
AND
NON SOLUBLE

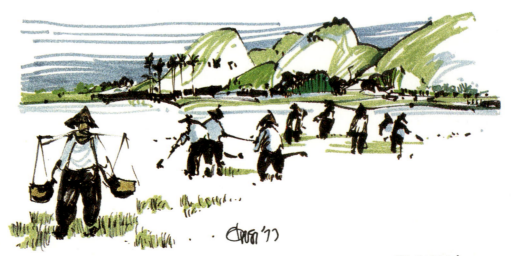

TAIWAN

THE USE OF COLORED PENCILS IN ENHANCING THE SKETCH IS EFFECTIVE BUT MORE TEDIOUS THAN WATERCOLORS OR MARKERS. COLORED PENCILS ARE USED PRIMARILY TO TOUCH IN COLOR ON OTHERWISE MONOCHROMATIC SKETCHES. THIS IS PARTICULARLY USEFUL WITH SKETCHES DONE ON TINTED PAPERS. BECAUSE OF THE VARIETY OF TYPES OF "LEADS" IN PENCILS, DIFFERENT EFFECTS CAN BE ACHIEVED. SOME LEADS ARE SOFT AND WAXY IN TEXTURE WHILE OTHERS ARE CHALKY AND BRITTLE. IN ADDITION, THERE ARE LEADS THAT ARE WATER SOLUBLE AND CAN BE MANIPULATED AND BLENDED WITH THE ADDITION OF WATER GIVING THE APPEARANCE OF A RENDERING. WITH THIS TYPE OF PENCIL, EDGES AND ENTIRE PASSAGES CAN BE SOFTENED.

THE STROKES OF THE PENCIL CAN BECOME A VERY DEFINITE PART OF THE CHARACTER OF THE SKETCH. IN ADDITION, THE CAREFUL OVERLAYING OF DIFFERENT COLORS IN THE SAME AREA CAN PRODUCE SOME VERY INTERESTING COLORS AND TEXTURES.

OVERLAYING CAN BECOME TIME CONSUMING, BUT WHEN USED FOR TOUCHING IN COLOR ACCENTS IT CAN BE QUITE EFFECTIVE.

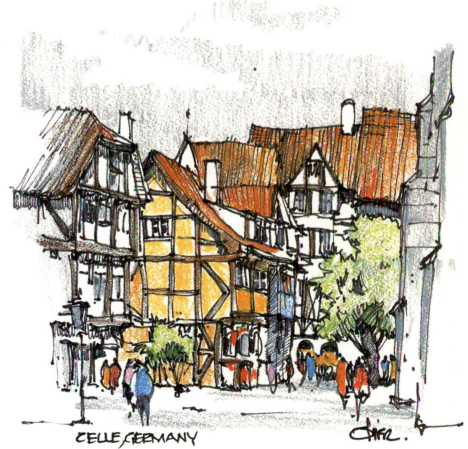

CELLE, GERMANY

91

SOME OF THE STROKES
OF THE COLORED PENCILS
DISSOLVE WITH THE APPLI-
CATION OF WATER WHILE
OTHERS REMAIN. THIS
GIVES THE APPEARANCE
OF MIXED MEDIA.

GRADATION OF VALUES IS
EASILY ACHIEVED USING
THIS MEDIA.

THE LIGHT AREA NEAR
THE CENTER DRAWS
THE EYE TO THE CENTER
OF INTEREST.

THE SIZE OF THE PALLETTE
OF COLORS LIMITS THE
COLORS ACHIEVED.

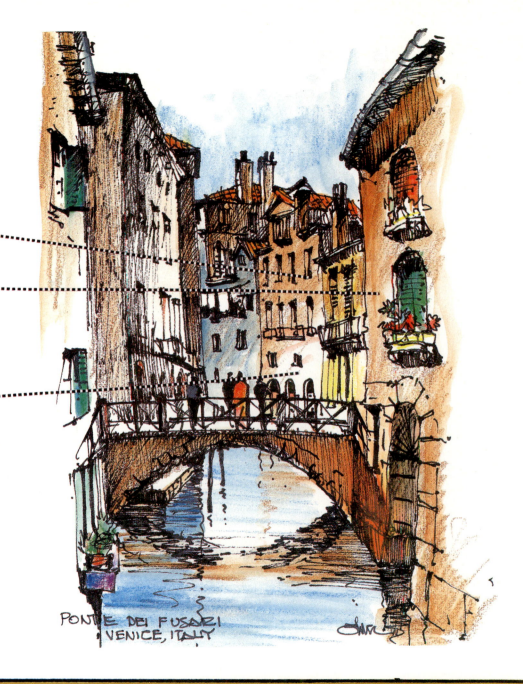

PONTE DEI FUSARI
VENICE, ITALY

LARGE BARREL MARKER - ULTRA FINE TIP - SKETCH PAPER

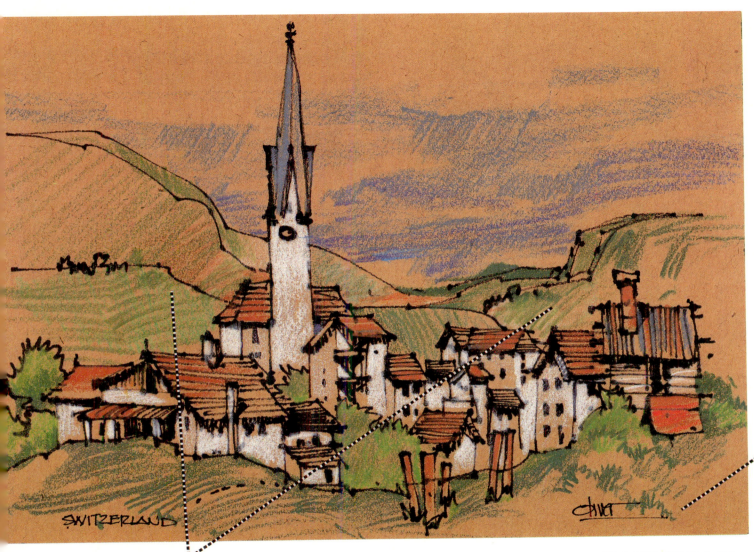

SWITZERLAND

THIS SKETCH
WAS DONE ON
BROWN WRAP-
PING PAPER.

THE STROKES
ARE USED TO
REINFORCE
THE GROUND
FORMS.

THE INTERPLAY OF THE ROOF FORMS
AND THE WALLS PROVIDES THE COMP-
OSITIONAL INTEREST IN THE SKETCH.
THE WHITE WALLS EMPHASISE THIS POINT.

SMALL BARREL MARKER - MEDIUM TIP - COLORED WRAPPING PAPER

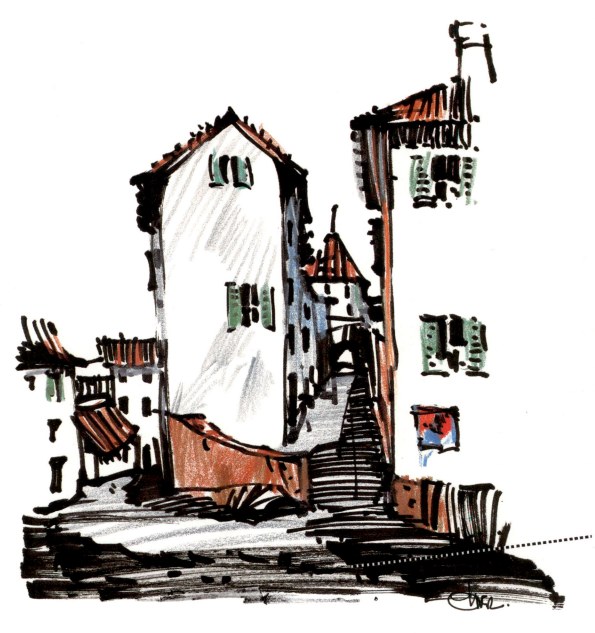

THIS TYPE OF SKETCH IS
VERY RAPID BUT STILL QUITE
STRONG WITH A MINIMUM
OF DETAIL.

THE LARGE WEDGE TIP
PROVIDES THE HEAVY
SKELETON TO SUPPORT
THE ELEMENTS IN THE
SKETCH. THE USE OF
COLOR WAS KEPT TO A
MINIMUM FORCING THE
WHITE OF THE BUILDINGS
TO ACT AS COLOR.

THE DARK SHADOW PRO-
VIDES A BASE FOR THE
STRONG WHITE ELEMENTS.

LARGE BARREL MARKER - BROAD TIP - HEAVY SKETCH PAPER.

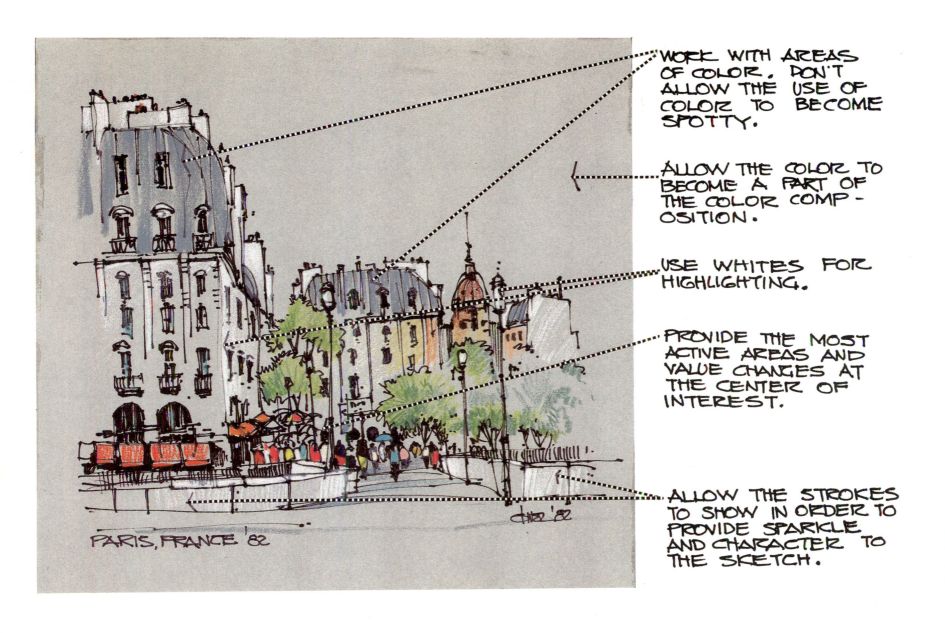

WORK WITH AREAS OF COLOR. DON'T ALLOW THE USE OF COLOR TO BECOME SPOTTY.

ALLOW THE COLOR TO BECOME A PART OF THE COLOR COMP- OSITION.

USE WHITES FOR HIGHLIGHTING.

PROVIDE THE MOST ACTIVE AREAS AND VALUE CHANGES AT THE CENTER OF INTEREST.

ALLOW THE STROKES TO SHOW IN ORDER TO PROVIDE SPARKLE AND CHARACTER TO THE SKETCH.

PARIS, FRANCE '82

SMALL BARREL MARKER - FINE TIP - TINTED CHARCOAL PAPER

95

NOTE THE WHITES THAT ARE LEFT.

THIS IS A GENERAL COMPOSITION OF ELEMENTS WITH NO PARTICULAR CENTER OF INTER-EST.

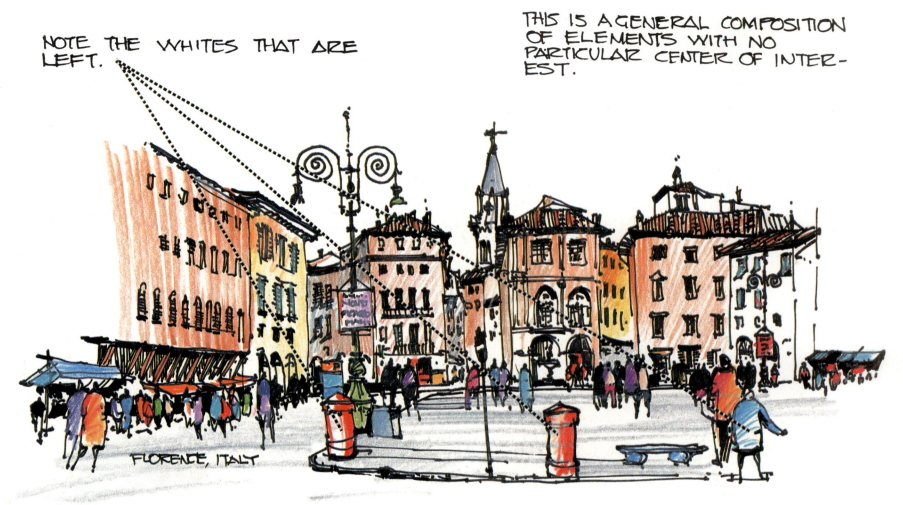

FLORENCE, ITALY

THE TENDENCY IS TO WANT TO COLOR ALL OF THE BUILDINGS ELABORATELY BUT THIS WAS HELD BACK IN ORDER TO EXPLOIT THE PEOPLE.

PIAZZA DE SANTA CROCE FLORENCE, ITALY. '81

96 SMALL BARREL MARKER - MEDIUM TIP - BRISTOL BOARD

THE FOCUS IS ON THE
WAGON SO THE COLOR-
ATION OF THE OTHER
PARTS IS KEPT TO A
MINIMUM.

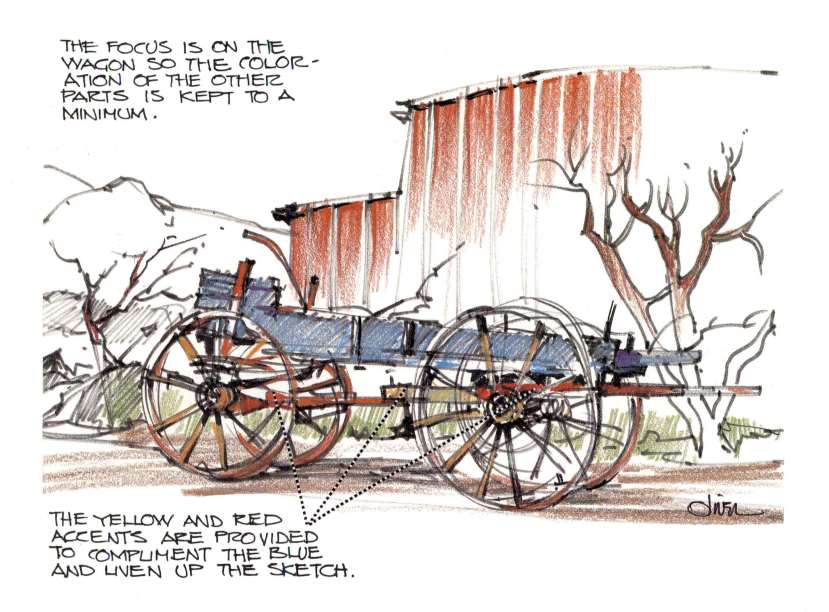

THE YELLOW AND RED
ACCENTS ARE PROVIDED
TO COMPLIMENT THE BLUE
AND LIVEN UP THE SKETCH.

THE DARKS INSIDE OF THE BARN AND IN THE SHADOW AREAS ARE IMPORTANT TO THE STRENGTH AND INTEREST OF THE SKETCH.

KEEP A VARIETY OF TONE ACROSS A SURFACE. COMBINE COLORS TO GIVE VARIETY AND INTEREST TO THE COLOR AREAS.

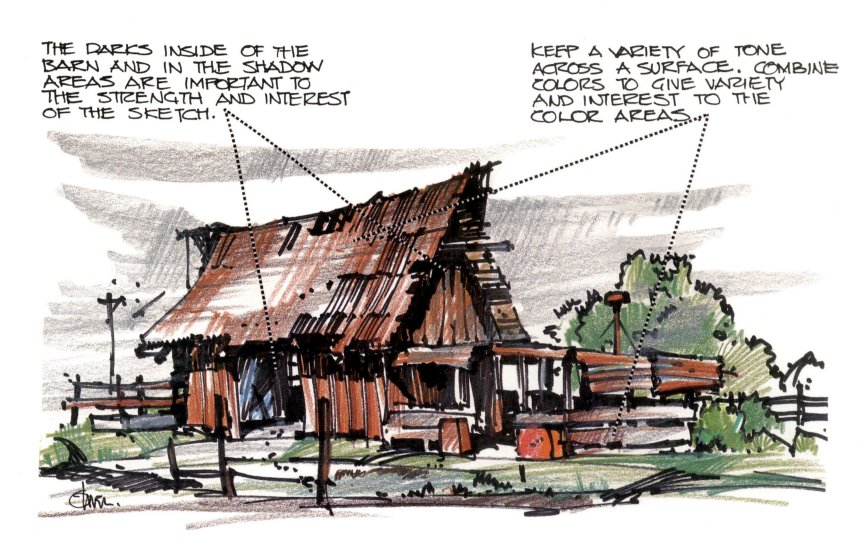

THE LARGE TIP SUGGESTS STRENGTH. THE APPLICATION OF COLOR WAS KEPT EQUALLY STRONG.

SMALL BARREL MARKER - LARGE TIP - MARKER PAPER

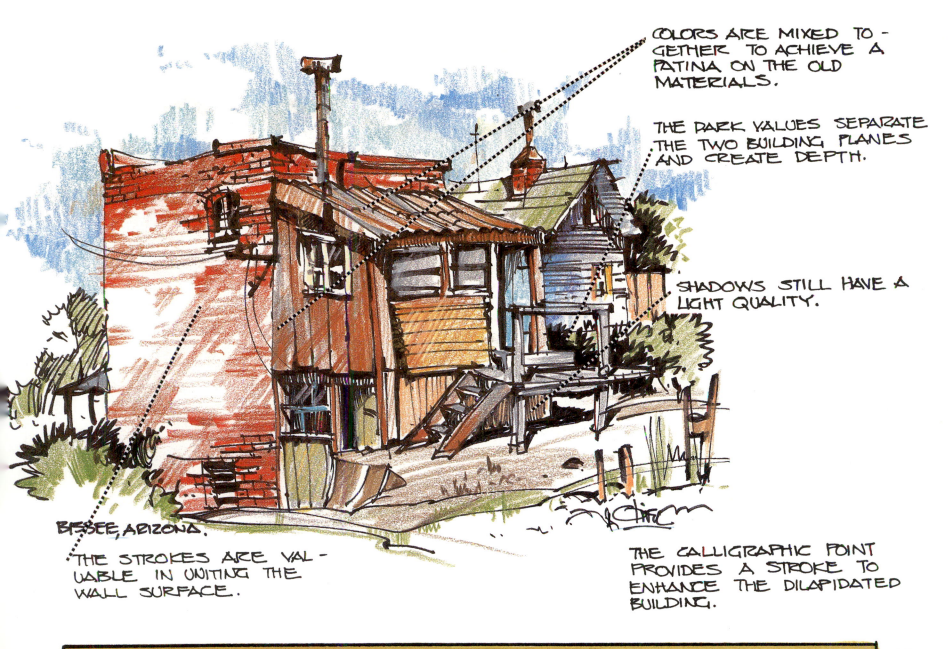

COLORS ARE MIXED TO-GETHER TO ACHIEVE A PATINA ON THE OLD MATERIALS.

THE DARK VALUES SEPARATE THE TWO BUILDING PLANES AND CREATE DEPTH.

SHADOWS STILL HAVE A LIGHT QUALITY.

BISBEE, ARIZONA.

THE STROKES ARE VAL-UABLE IN UNITING THE WALL SURFACE.

THE CALLIGRAPHIC POINT PROVIDES A STROKE TO ENHANCE THE DILAPIDATED BUILDING.

SMALL BARREL MARKER - WEDGE TIP - TYPING PAPER.

99

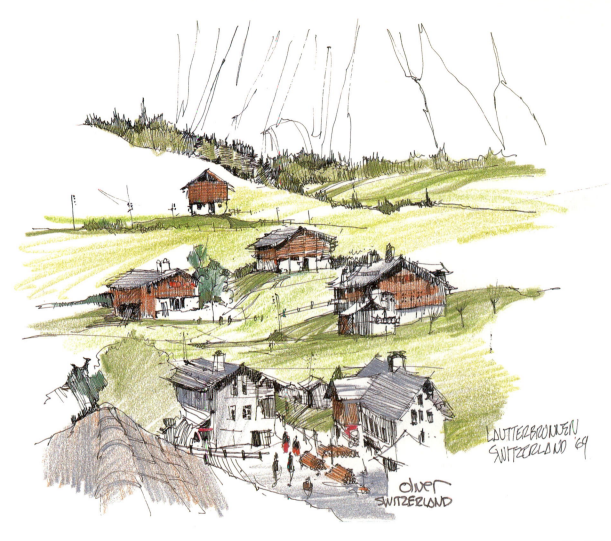

LAUTTERBRUNNEN
SWITZERLAND '69

oliver
SWITZERLAND

THE WHITES ARE LEFT TO
PROVIDE SPARKLE TO THE
SKETCH.

COLOR WAS USED SPARINGLY
IN ORDER TO HONOR THE
VERY FINE LINE OF THE
PEN STROKE.

TECHNICAL DRAFTING PEN - ULTRA FINE TIP - DRAWING PAPER

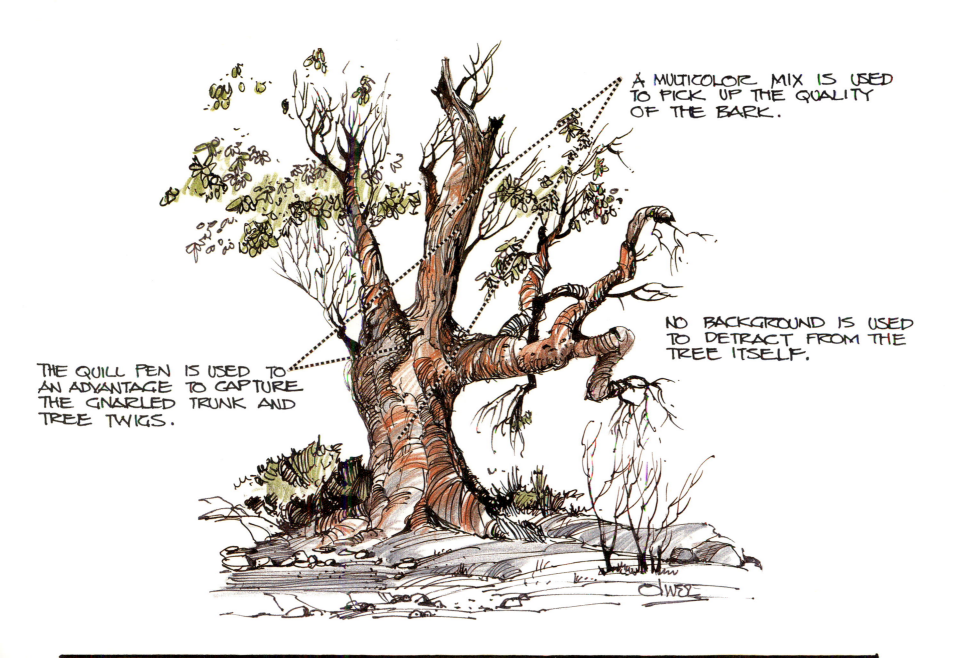

A MULTICOLOR MIX IS USED TO PICK UP THE QUALITY OF THE BARK.

NO BACKGROUND IS USED TO DETRACT FROM THE TREE ITSELF.

THE QUILL PEN IS USED TO AN ADVANTAGE TO CAPTURE THE GNARLED TRUNK AND TREE TWIGS.

QUILL WRITING PEN - FINE FLEXIBLE POINT - BRISTOL BOARD 101

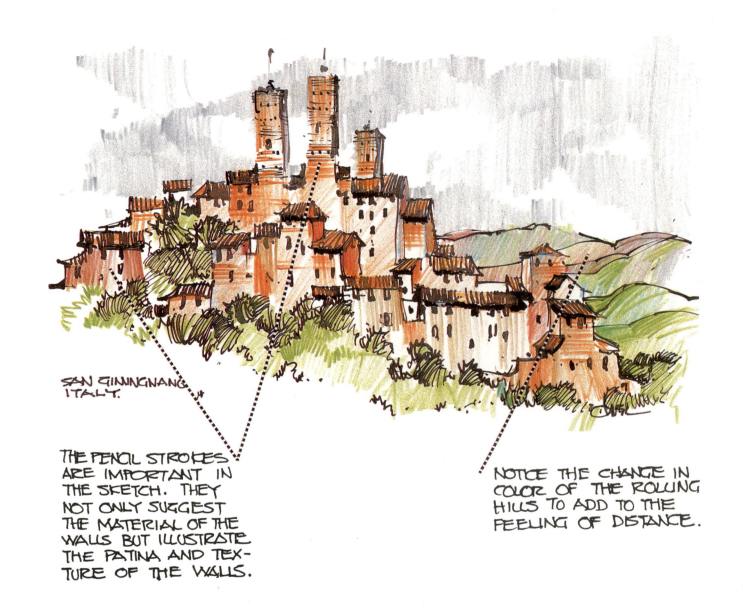

SAN GININGNANG
ITALY.

THE PENCIL STROKES
ARE IMPORTANT IN
THE SKETCH. THEY
NOT ONLY SUGGEST
THE MATERIAL OF THE
WALLS BUT ILLUSTRATE
THE PATINA AND TEX-
TURE OF THE WALLS.

NOTICE THE CHANGE IN
COLOR OF THE ROLLING
HILLS TO ADD TO THE
FEELING OF DISTANCE.

MEDIUM BARREL SKETCH PEN - FLEXIBLE POINT - HEAVY SKETCH PAPER

THE SIDE OF THE PENCIL POINT WAS USED FOR THE SKY.

THE WHITE OF THE PAPER WAS LEFT BECAUSE THE SCENE WAS COLD AND SNOW WAS SCATTERED ABOUT.

THE MERCHANDISE PROVIDED THE COLOR.

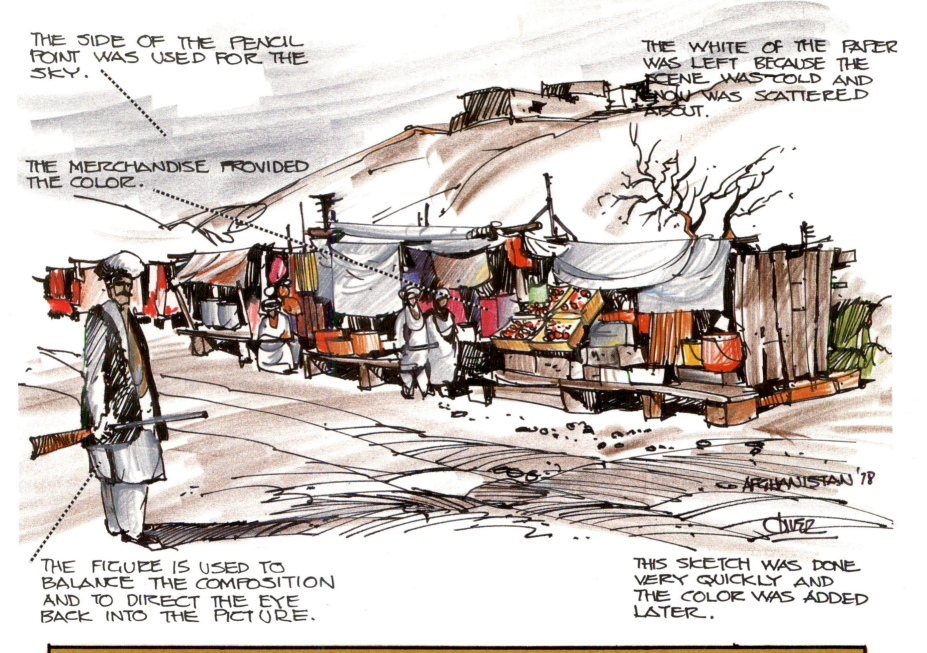

AFGHANISTAN '78

THE FIGURE IS USED TO BALANCE THE COMPOSITION AND TO DIRECT THE EYE BACK INTO THE PICTURE.

THIS SKETCH WAS DONE VERY QUICKLY AND THE COLOR WAS ADDED LATER.

WRITING FOUNTAIN PEN — MEDIUM RIGID POINT — SKETCH PAPER | 103

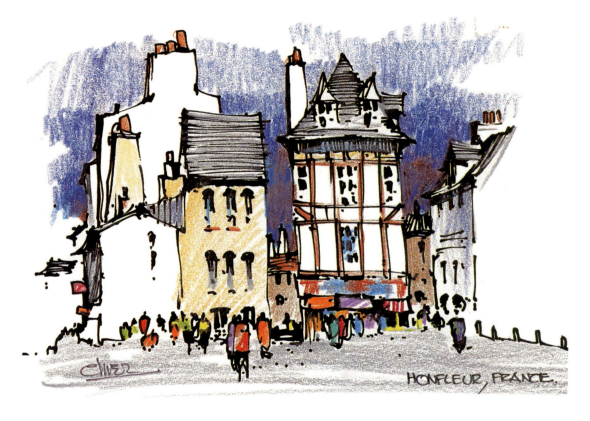

HONFLEUR, FRANCE.

THE DETAIL WAS KEPT
SIMPLE DUE TO THE SIZE
OF THE SKETCH AND THE
SIZE OF THE POINT ON
THE PEN.

THE SKY WAS PURPOSELY
MADE DARK TO REINFORCE
THE WHITE BUILDINGS.

THE LARGE AREAS OF
THE BUILDINGS REINFORCE
THE BUSY QUALITY OF THE
FIGURES IN CONTRAST.

SPEED BALL PEN — SMALL POINT B-6 — SKETCH PAPER

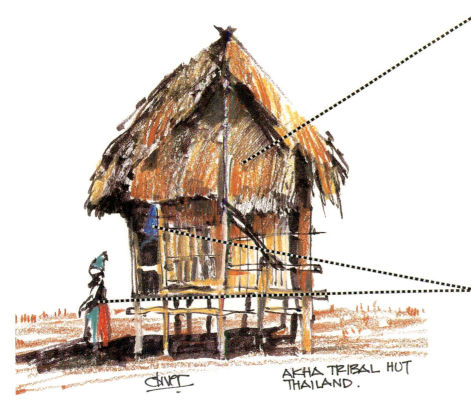

THE GRASS ROOF IS
REPRESENTED BY
BOTH DRY BRUSH AND
COLORED PENCIL
STROKES.

BLACK IS AN IMPORTANT
INGREDIENT IN THIS SKETCH.

THE SPARKS OF BRIGHT
COLORS ARE JEWELS IN
THE OVERALL COLOR OF
THE BUILDING.

AKHA TRIBAL HUT
THAILAND.

THE WATER SOLUBLE PENCILS
WORK WELL IN DEPICTING WATER
SURFACES WITH HARD AN SOFT
EDGES EASILY ATTAINED.

THE STRONG STROKES OF THE
LARGER FELT TIP POINT DOMINATE
THE SKETCH WITH THE COLOR
ACTING AS A SUPPORT.

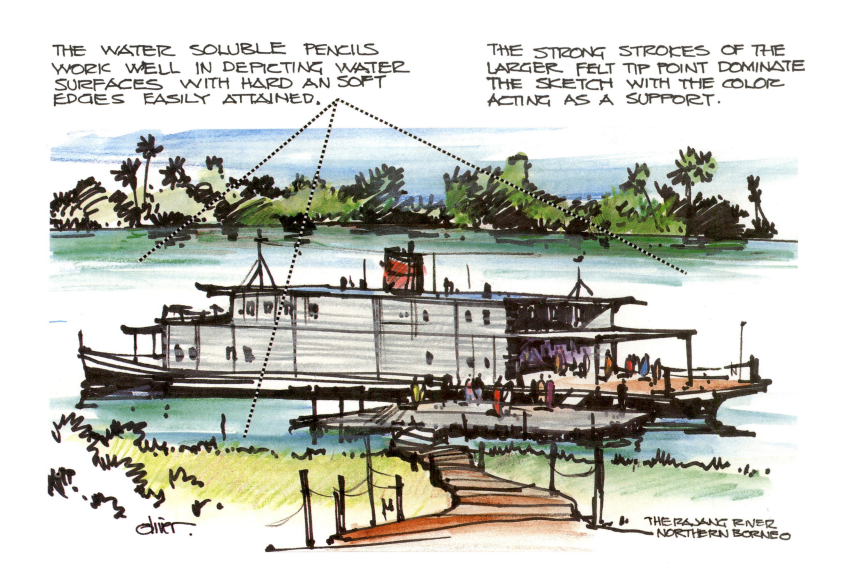

THE RAJANG RIVER
NORTHERN BORNEO

LARGE BARREL MARKER - MEDIUM TIP - DRAWING PAPER

THE WATER SOLUBLE PENCILS
PROVIDE A VARIETY OF
CHOICES BETWEEN HARD AND
SOFT EDGES, STROKES AND
TEXTURES.

A VARIATION OF COLOR THROUGH
THE VARIOUS SURFACES ARE
ALSO EASY TO ATTAIN.

BY ADDING WATER WASH TO THE
PENCIL COLOR, A TRANSPARENCY
IS RESTORED ALLOWING THE
INK LINES TO SHOW THROUGH.

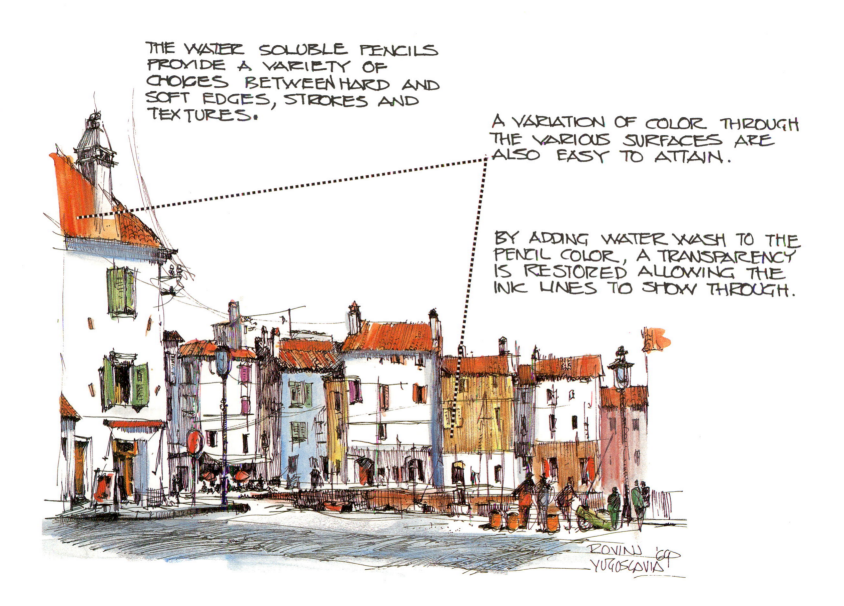

ROVINJ '69
YUGOSLAVIA

TECHNICAL DRAFTING PEN - ULTRA FINE TIP - SKETCH PAPER 107

THE SKY IS SOMEWHAT
WILD, BUT IT IS ONLY A
SKETCH.

NOTICE THE SUBTLE VALUE
CHANGE IN THE ADJACENT
PLANES OF THE BUILDINGS.

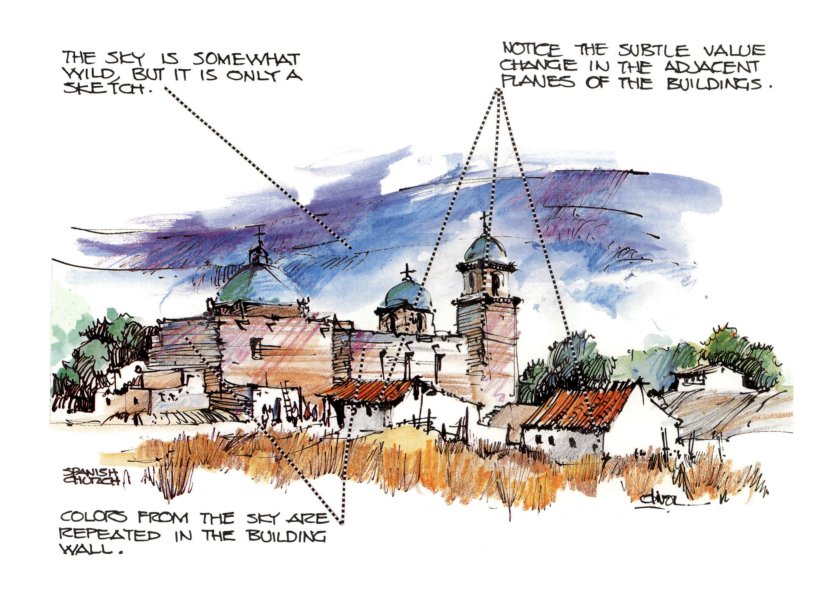

SPANISH
CHURCH

COLORS FROM THE SKY ARE
REPEATED IN THE BUILDING
WALL.

MEDIUM BARREL SKETCH PEN -FLEXIBLE TIP - BRISTOL BOARD

A VARIETY OF COLORS ARE USED TO ENHANCE THE DETERIORATED LOOK OF THE BUILDING.

PEN STROKES ARE KEPT LOOSE AND OVERLAP TO EXPRESS THE STATE OF DISREPAIR OF THE BUILDING.

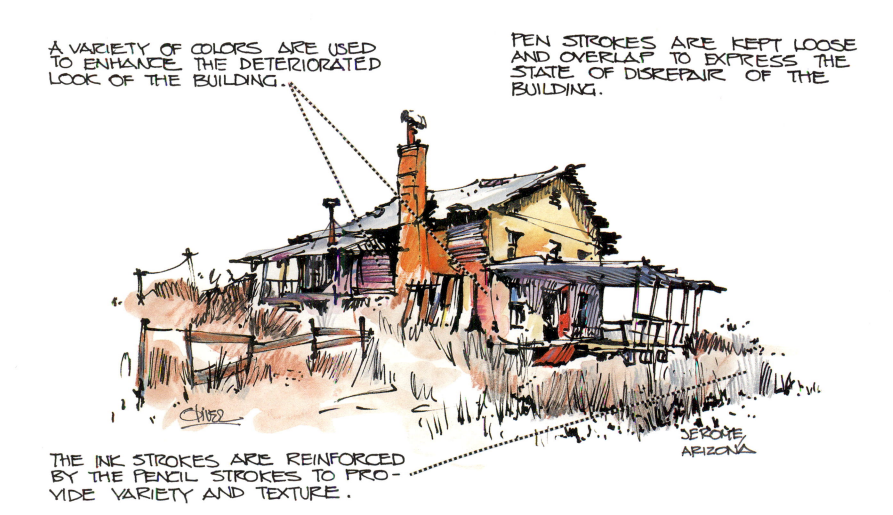

JEROME ARIZONA

THE INK STROKES ARE REINFORCED BY THE PENCIL STROKES TO PROVIDE VARIETY AND TEXTURE.

SPEEDBALL PEN - SMALL POINT B-6 - MARKER PAPER

THE STROKES ARE APPLIED
AFTER A WATER WASH
SO THE TEXTURE OF THE
BOARDS CAN BE EXPRESSED.

A VARIETY OF COLORS WAS
USED IN THE DISTANT HILLS
AND THEN THEY WERE
BLENDED WITH A WATER
WASH.

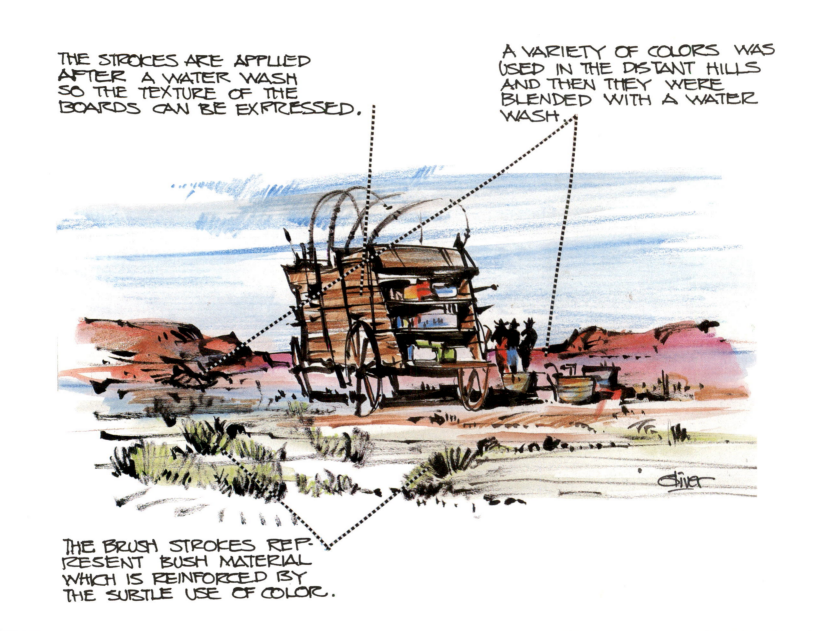

THE BRUSH STROKES REP-
RESENT BUSH MATERIAL
WHICH IS REINFORCED BY
THE SUBTLE USE OF COLOR.

WATERCOLOR PAINT BRUSH - SMALL HAIR #1 - DRAWING PAPER

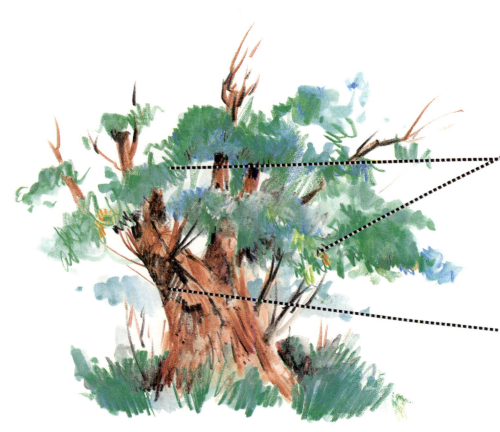

THE COLORS SHOWN ARE
SOMEWHAT RAW. THIS IS
DUE TO THE LIMITED COLORS
AVAILABLE IN A SMALL
SET.

THE TEXTURE OF THE FOLIAGE
IS ACHIEVED BY BOTH WET
AND DRY STROKES.

BLACK WAS USED TO PICK
OUT THE TEXTURE IN THE
TREE TRUNK.

MIXED MEDIA

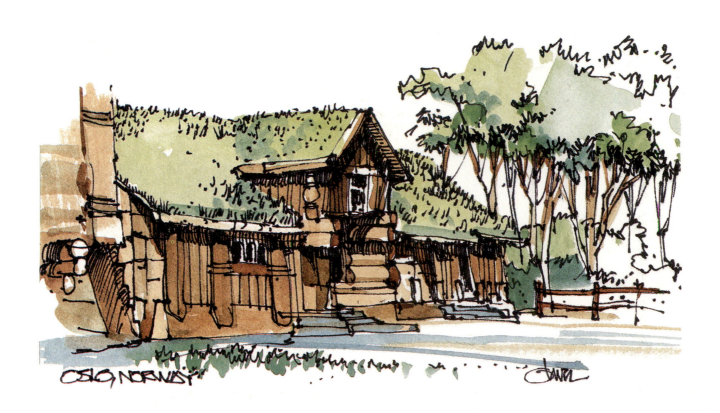

OSLO NORWAY

112

COLORED PENCIL
OVER MARKER

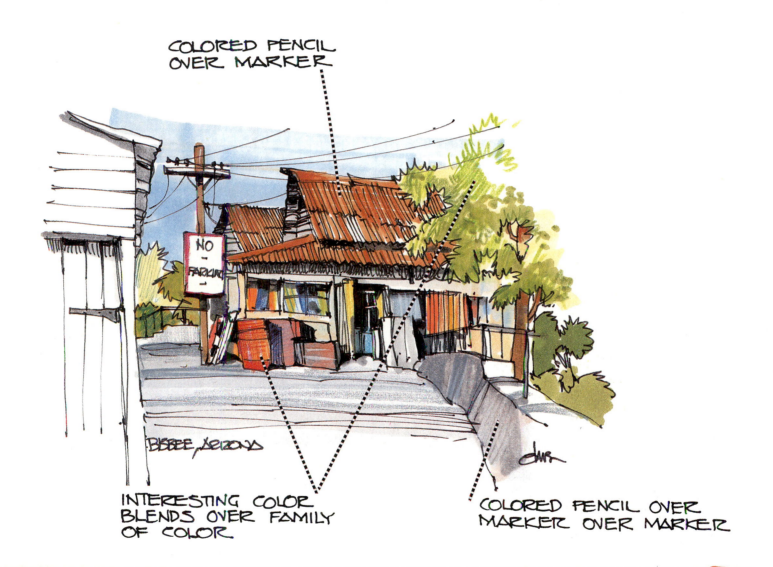

BISBEE, ARIZONA

INTERESTING COLOR
BLENDS OVER FAMILY
OF COLOR

COLORED PENCIL OVER
MARKER OVER MARKER

SMALL BARREL MARKER - MEDIUM TIP - MARKER PAPER 113

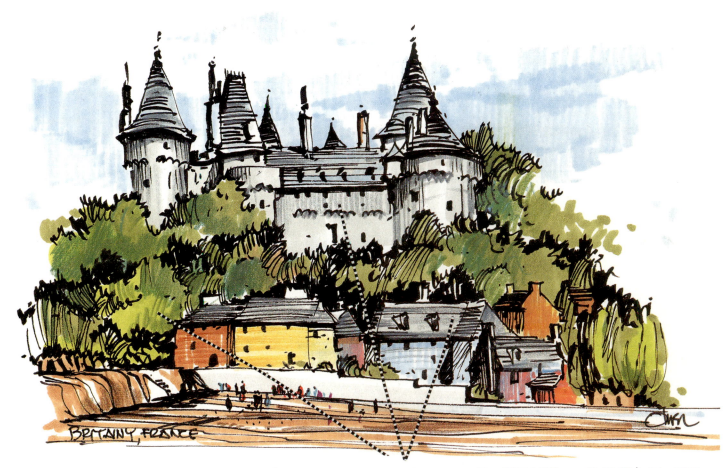

BRITANY, FRANCE

COLORED MARKER WITH COLORED PENCIL OVERLAYED

SMALL BARREL MARKER - WEDGE TIP - MARKER PAPER

PENCIL APPLIED WITH TEXTURED SURFACE UNDER
SKETCH PAPER RENDERS TEXTURE ON PAPER
SURFACE.

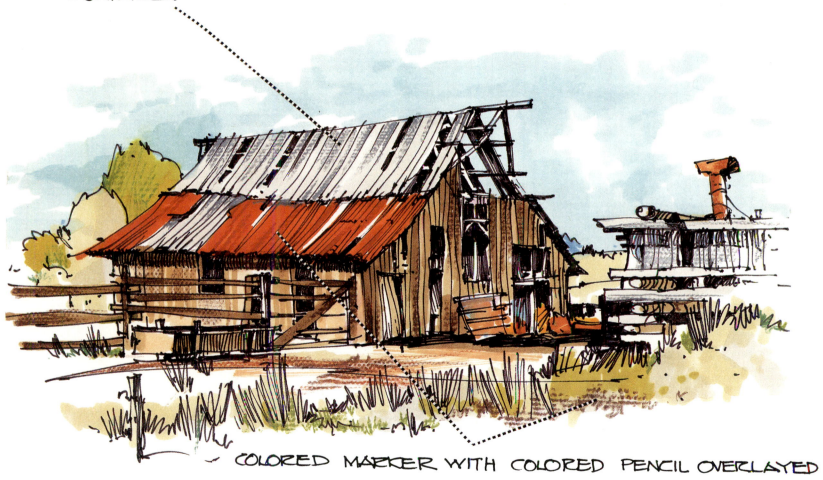

COLORED MARKER WITH COLORED PENCIL OVERLAYED

SMALL BARREL MARKER- FINE TIP POINT- MARKER PAPER

8 SPECIAL SUBJECTS

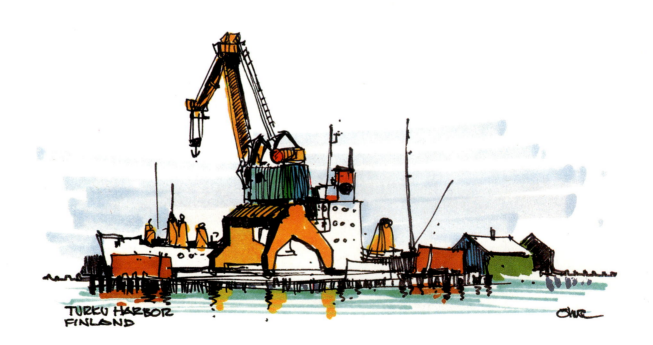

TURKU HARBOR
FINLAND

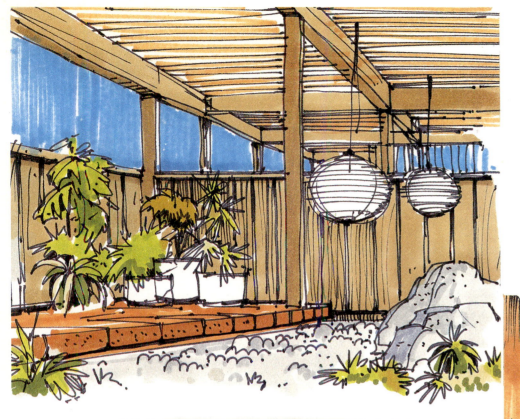

QUICK FREEHAND ARCHITECTURAL
CONCEPTUAL SKETCHES - THESE
SHOULD NOT BE CONFUSED WITH
FINISHED RENDERINGS.

SKETCHES WERE DONE WITH
FELT MARKER AND FINE TIP.

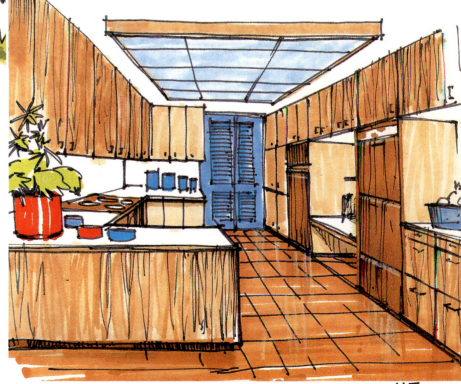

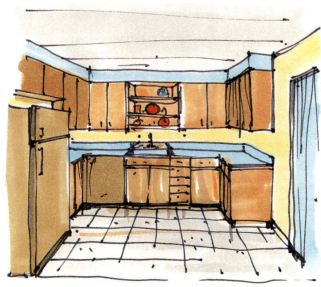

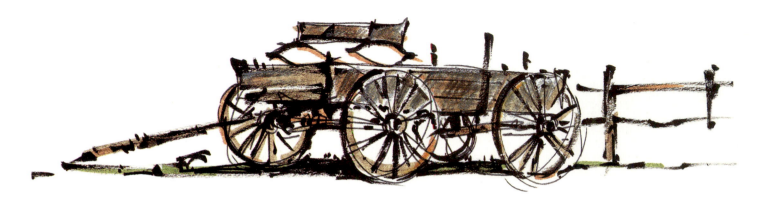

FELT MARKER

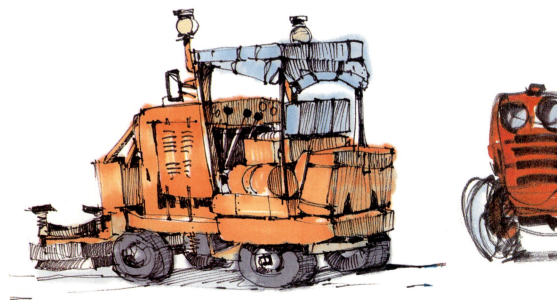

FELT MARKER

FELT MARKER

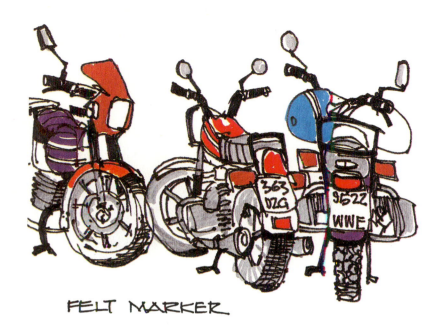

FELT MARKER

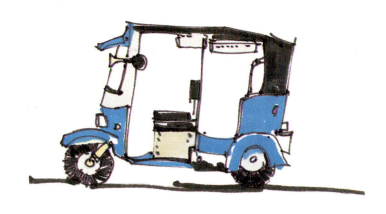

FELT MARKER

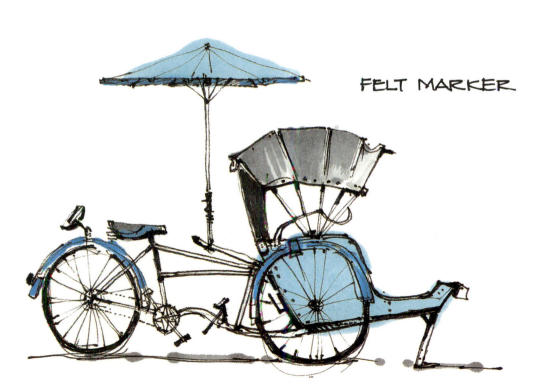

FELT MARKER

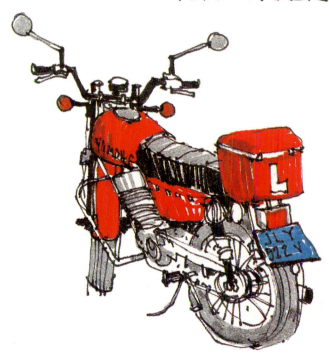

119

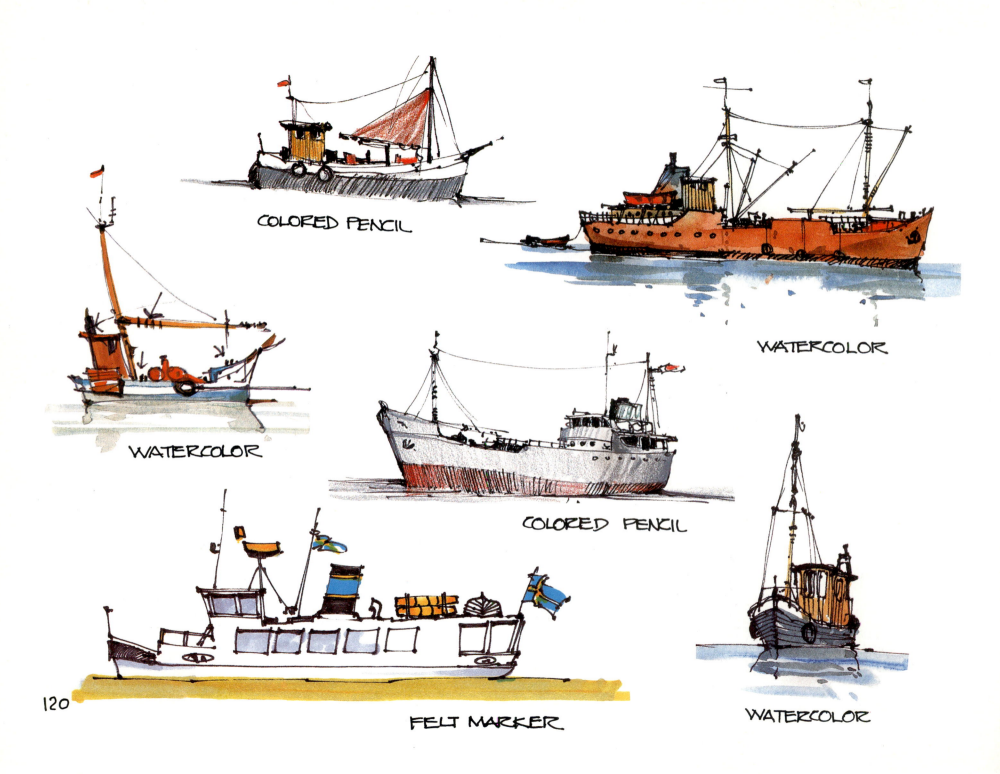

COLORED PENCIL

WATERCOLOR

WATERCOLOR

COLORED PENCIL

FELT MARKER

WATERCOLOR

120

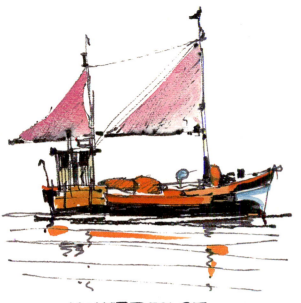

WATERCOLOR

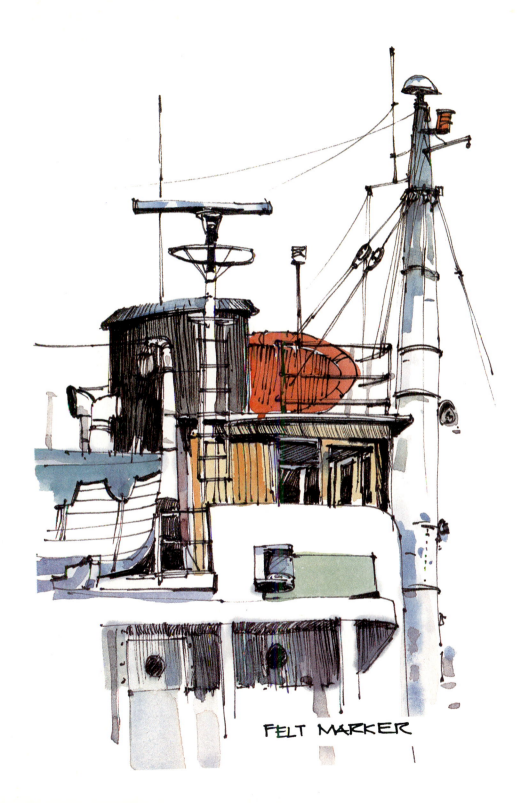

FELT MARKER

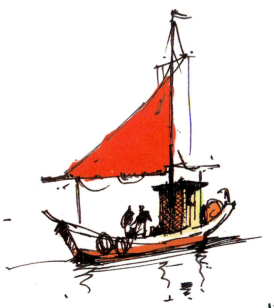

FELT MARKER

121

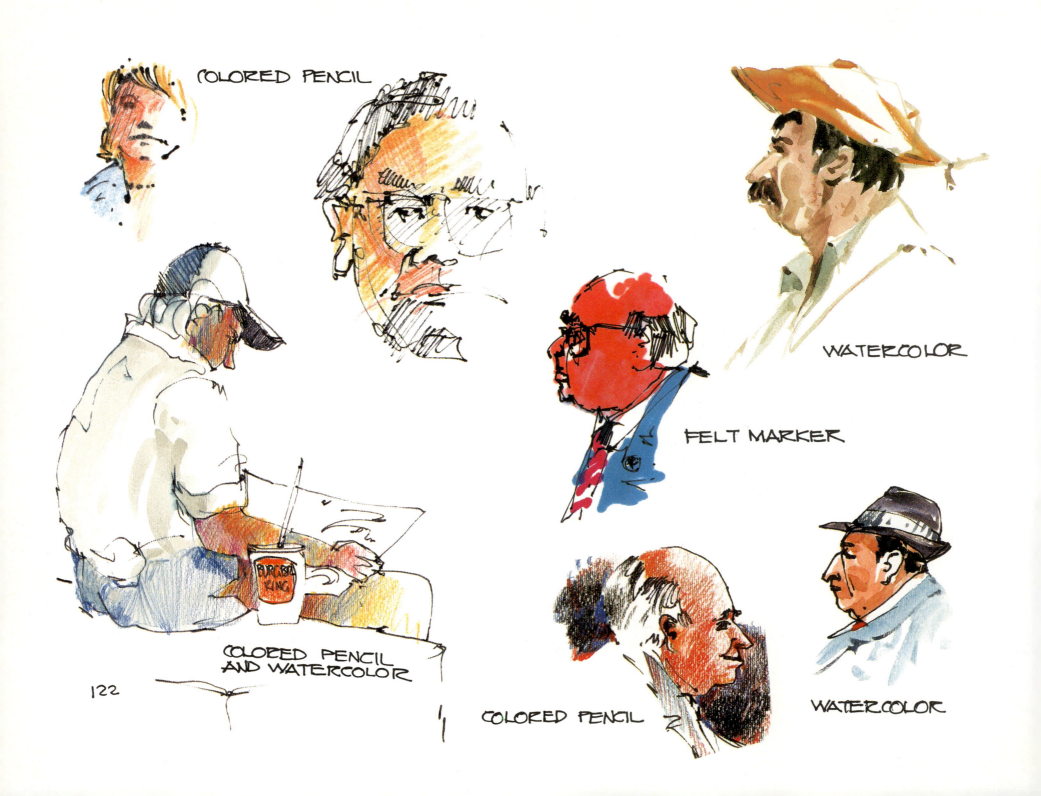

COLORED PENCIL

WATERCOLOR

FELT MARKER

COLORED PENCIL
AND WATERCOLOR

COLORED PENCIL

WATERCOLOR

BURGER KING

122

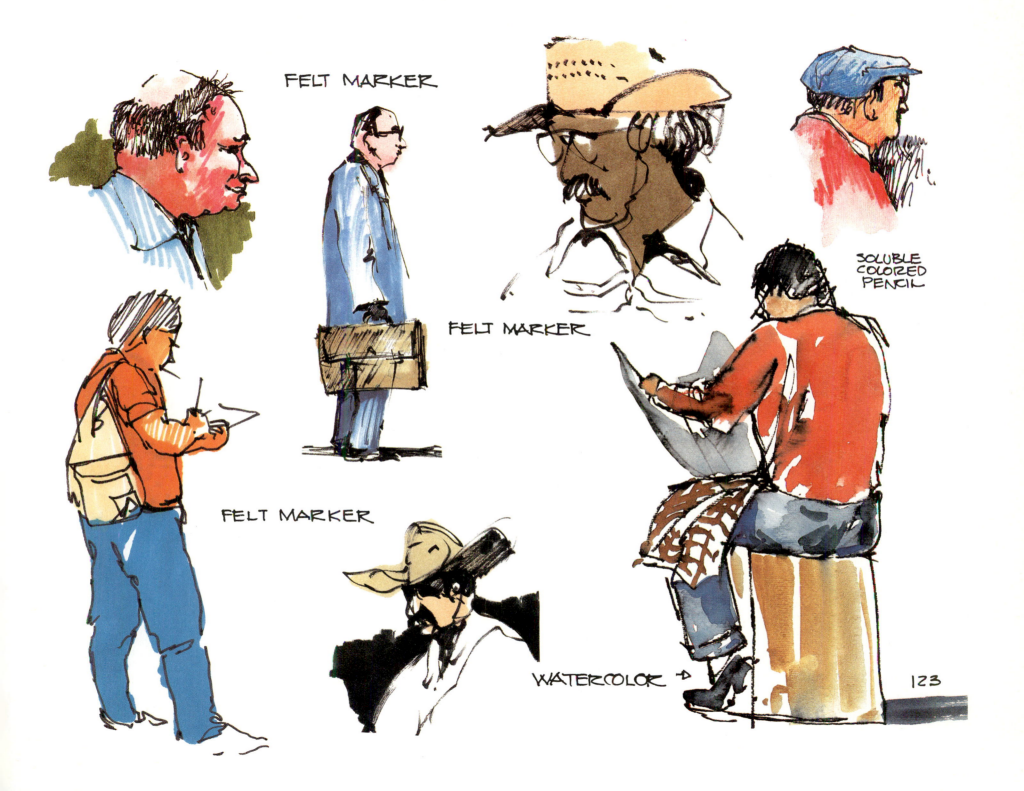

FELT MARKER

FELT MARKER

SOLUBLE COLORED PENCIL

FELT MARKER

WATERCOLOR

123

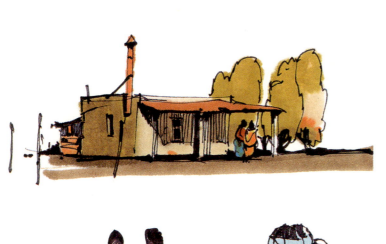

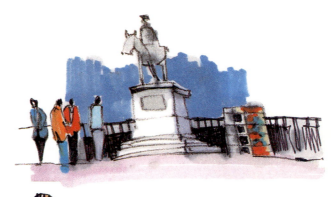

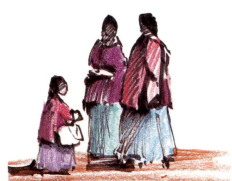

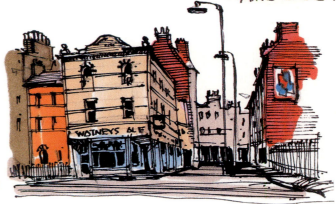

COLORED PENCIL

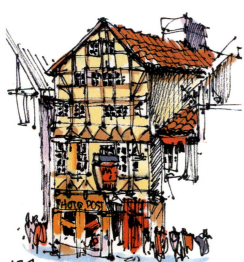

ALL SKETCHES ARE DONE
WITH FELT MARKERS EXCEPT
AS NOTED.

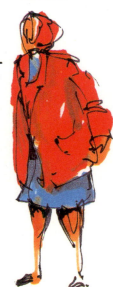

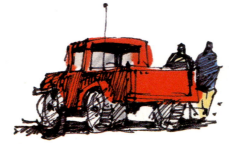

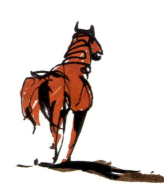

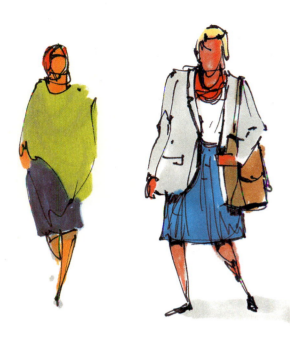

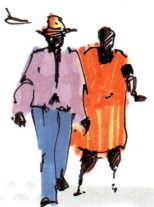 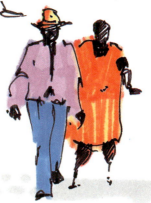

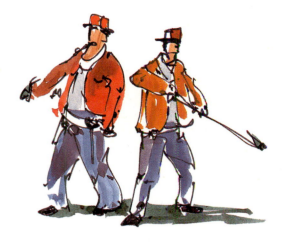

FELT
MARKER

WATERCOLOR

FELT MARKER

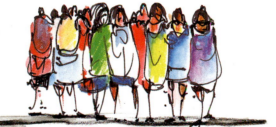

SOLUBLE COLORED PENCIL

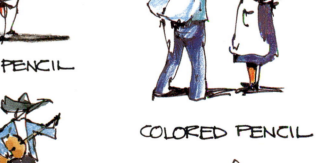

COLORED PENCIL

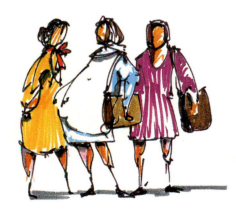

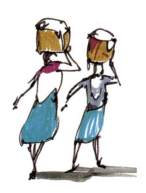

WATERCOLOR

FELT MARKER

FELT MARKER

WATERCOLOR

125

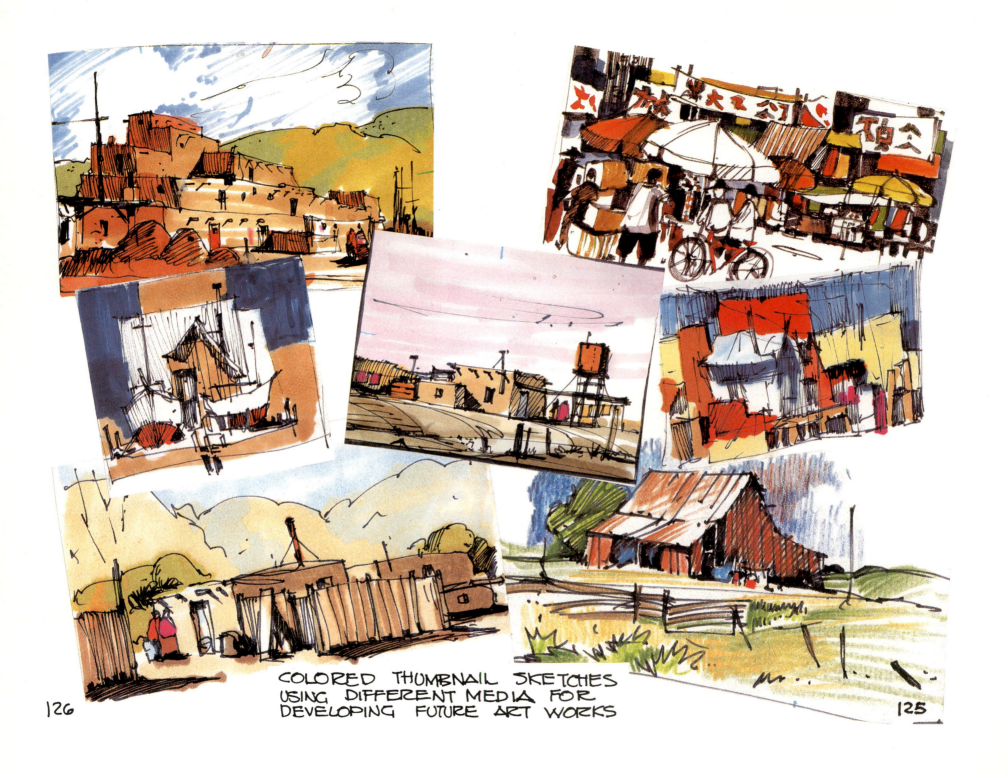

COLORED THUMBNAIL SKETCHES
USING DIFFERENT MEDIA FOR
DEVELOPING FUTURE ART WORKS

126

125

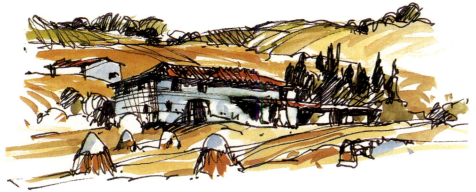

WATERCOLOR

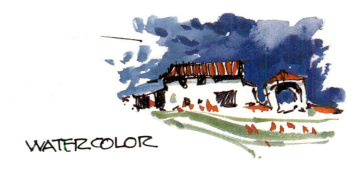

WATERCOLOR

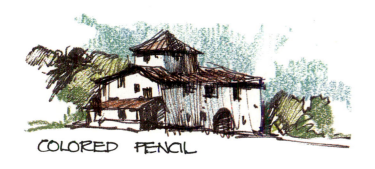

COLORED PENCIL

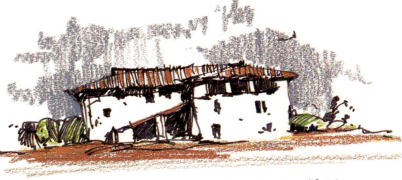

COLORED PENCIL

QUICK SKETCHES MADE IN PASSING
THROUGH THE COUNTRYSIDE AND
COLOR ADDED LATER.

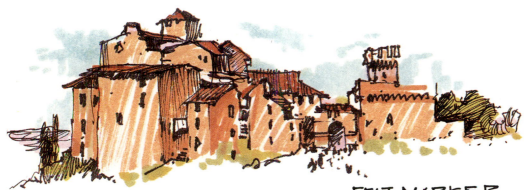

FELT MARKER

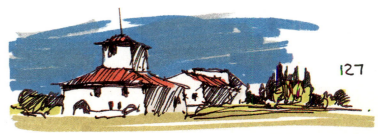

127

FELT MARKER

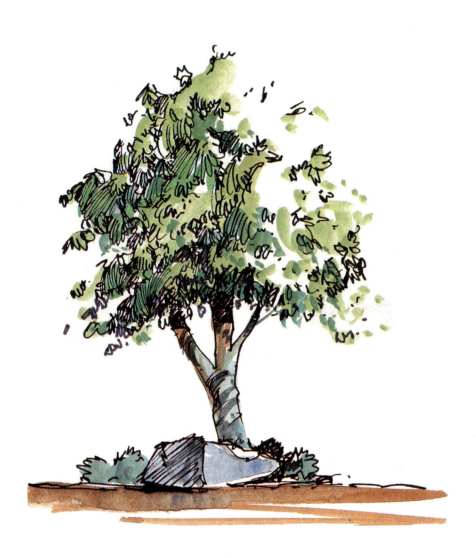

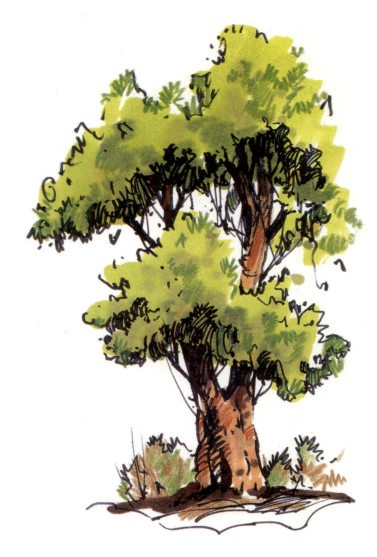

WATERCOLOR

MIXED MEDIA
MARKER AND
COLORED PENCIL

128

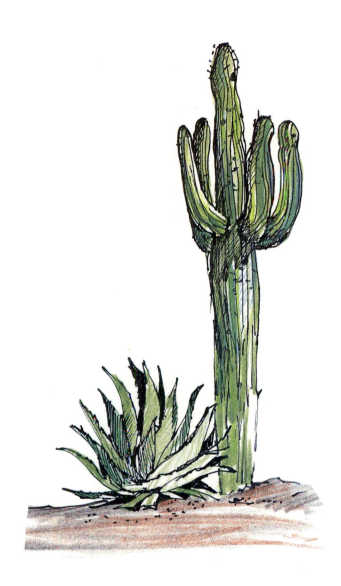

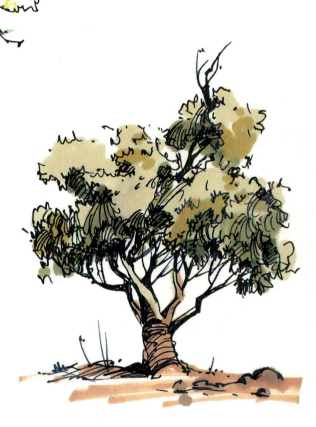

COLORED PENCIL

WATER SOLUBLE
COLORED PENCIL

FELT MARKER

129

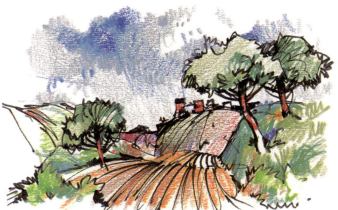

COLORED PENCIL

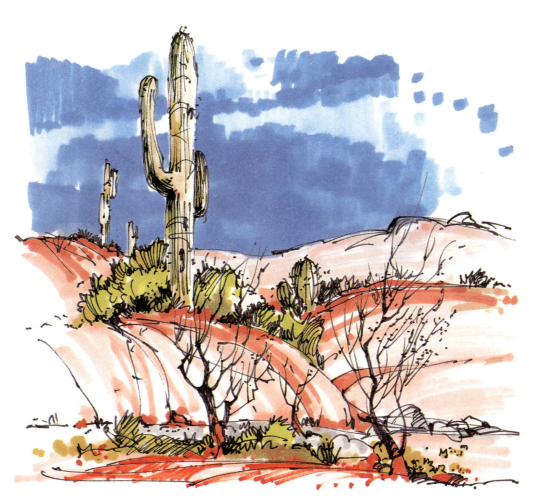

COLORED MARKER

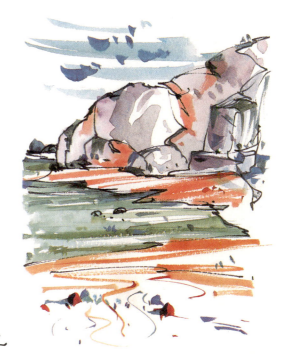

WATERCOLOR

130

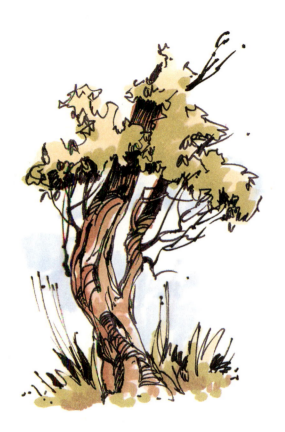

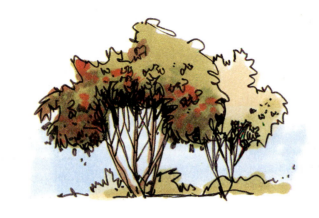

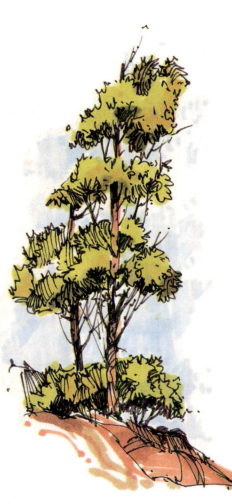

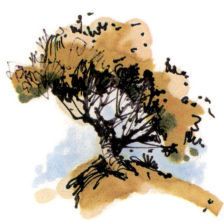

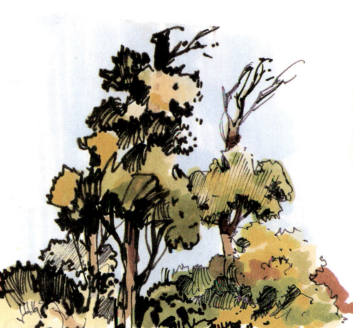

FINE AND MEDIUM TIP PENS
COLORED FELT MARKERS

131

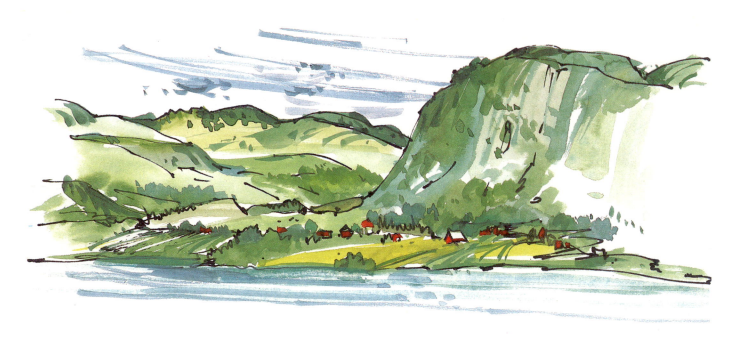

WATERCOLOR.

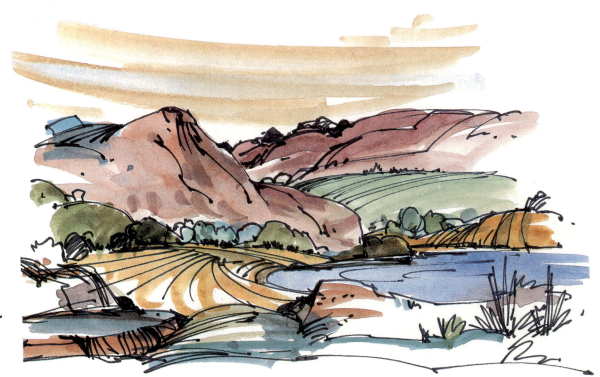

WATERCOLOR

132

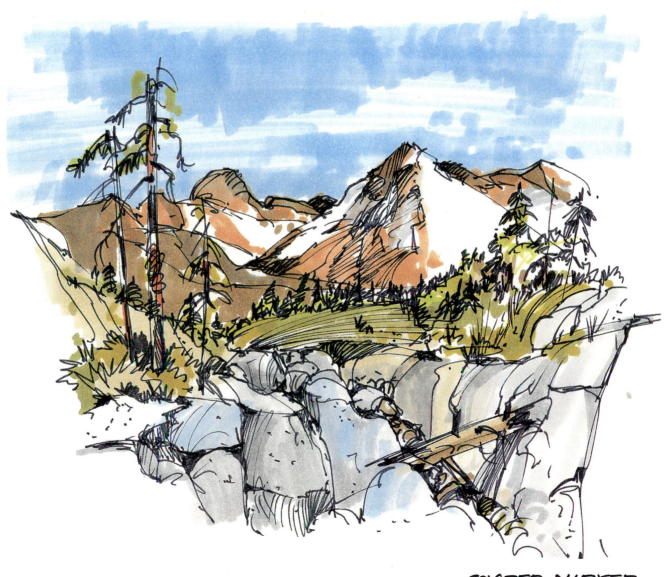

COLORED MARKER

133

9 SKETCH PORTFOLIO

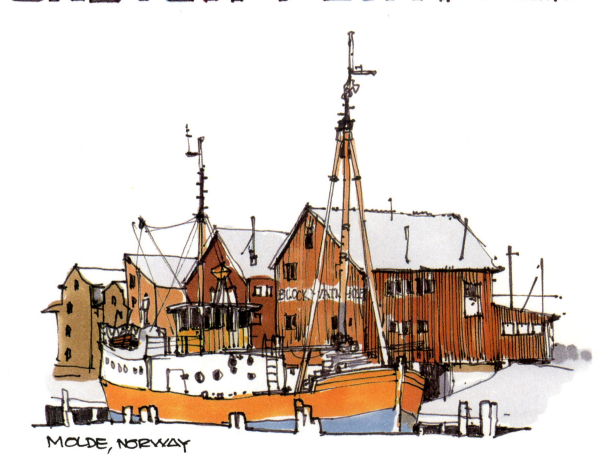

MOLDE, NORWAY

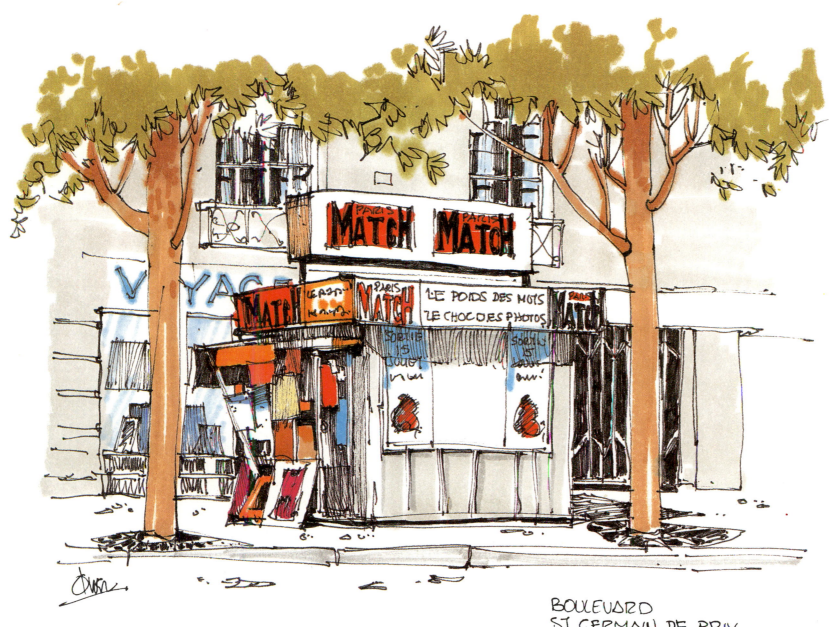

MARKER

BOULEVARD
ST. GERMAIN DE PRIX
PARIS '81

135

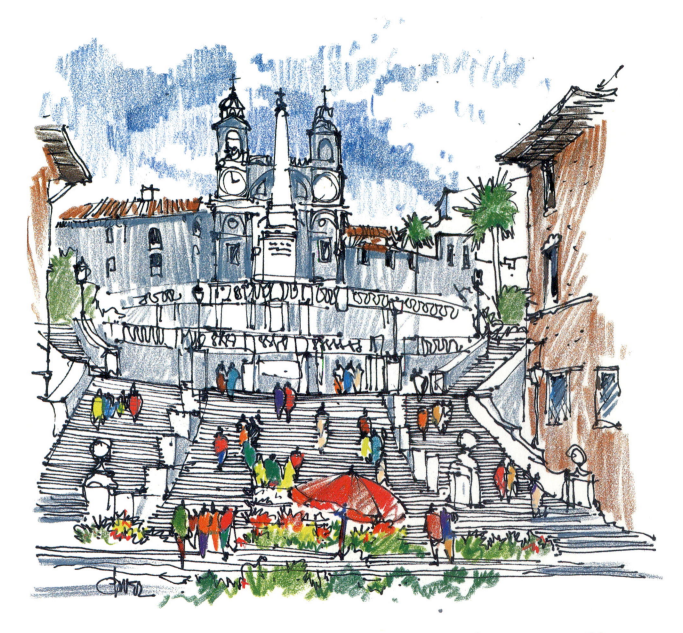

136

THE SPANISH STEPS
ROME ITALY '81

COLORED PENCIL

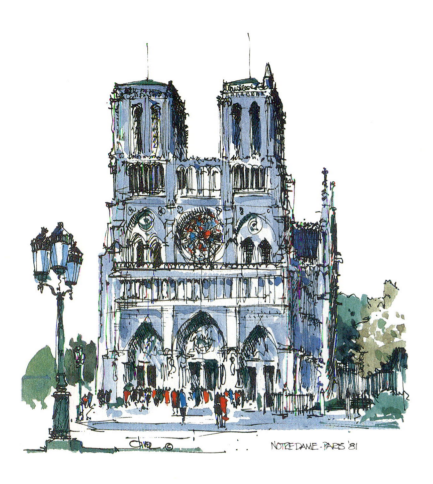

WATERCOLOR

NOTREDAME - PARIS '81

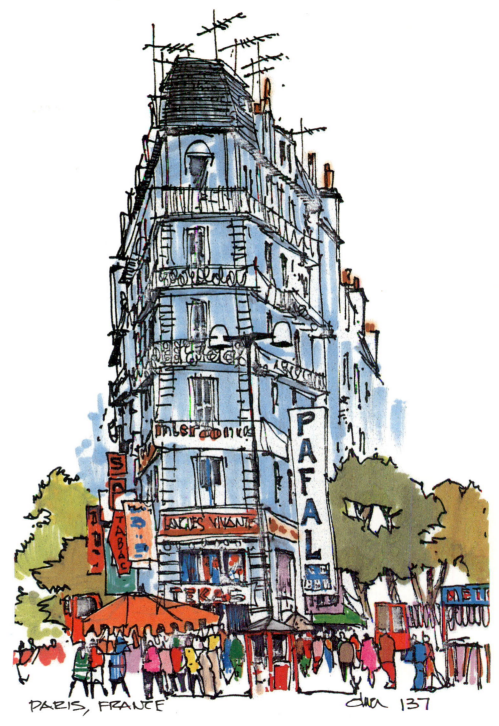

MARKER

PARIS, FRANCE

137

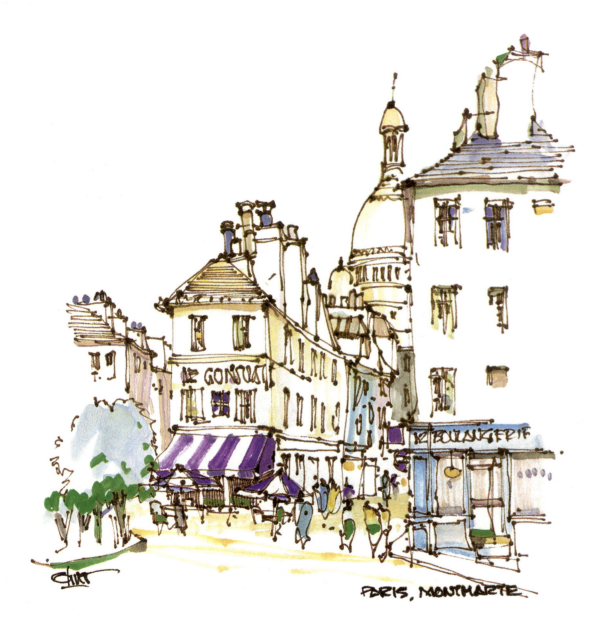

PARIS, MONTMARTE

WATERCOLOR ON SUMI PAPER

138

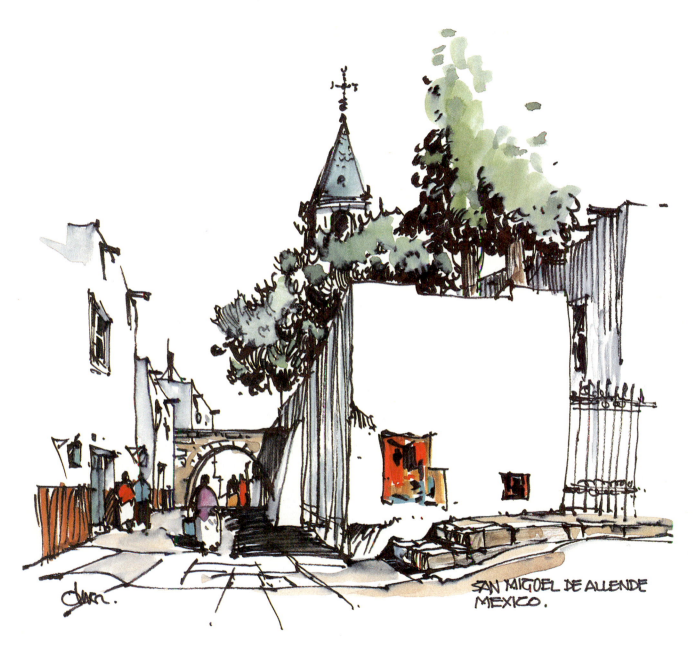

SAN MIGUEL DE ALLENDE
MEXICO.

WATERCOLOR.

139

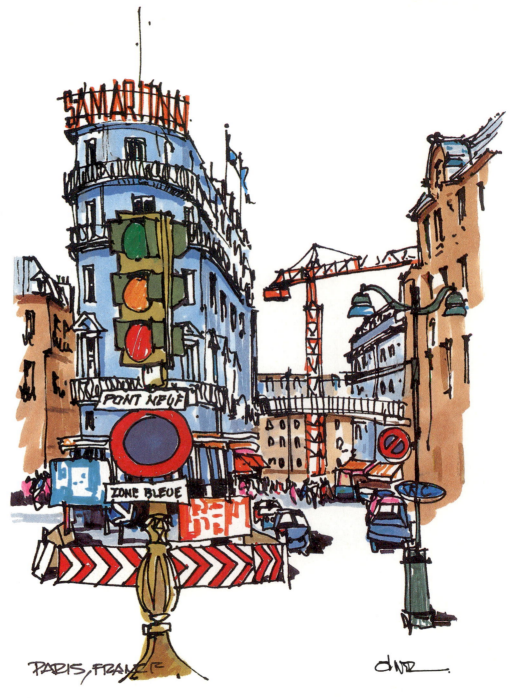

140

PARIS, FRANCE

MARKER.

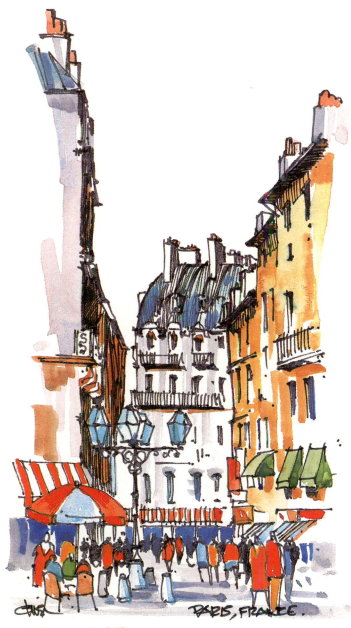

WATERCOLOR.

PARIS, FRANCE.

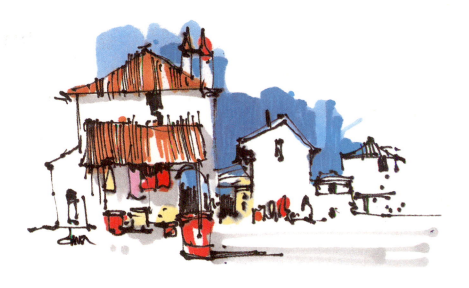

MARKER ON SUMI PAPER

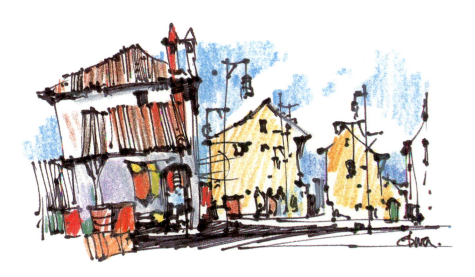

COLORED PENCIL ON SUMI PAPER

141

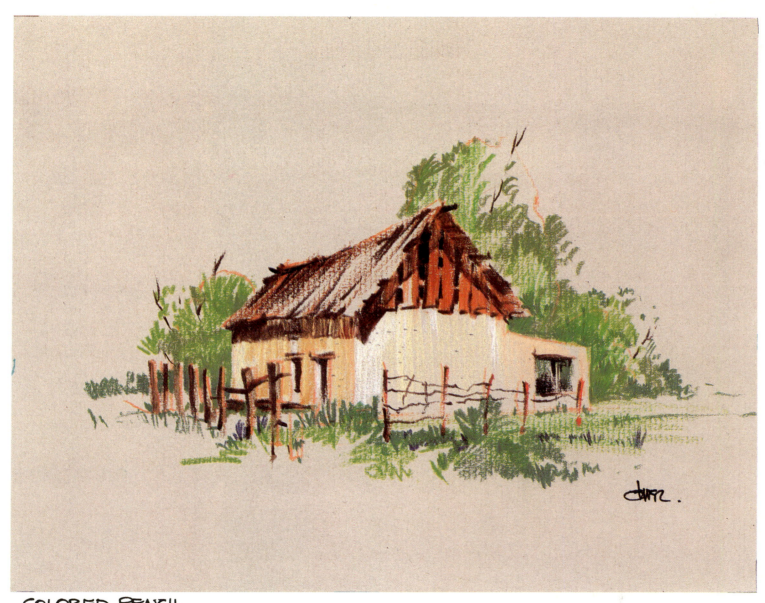

COLORED PENCIL

142

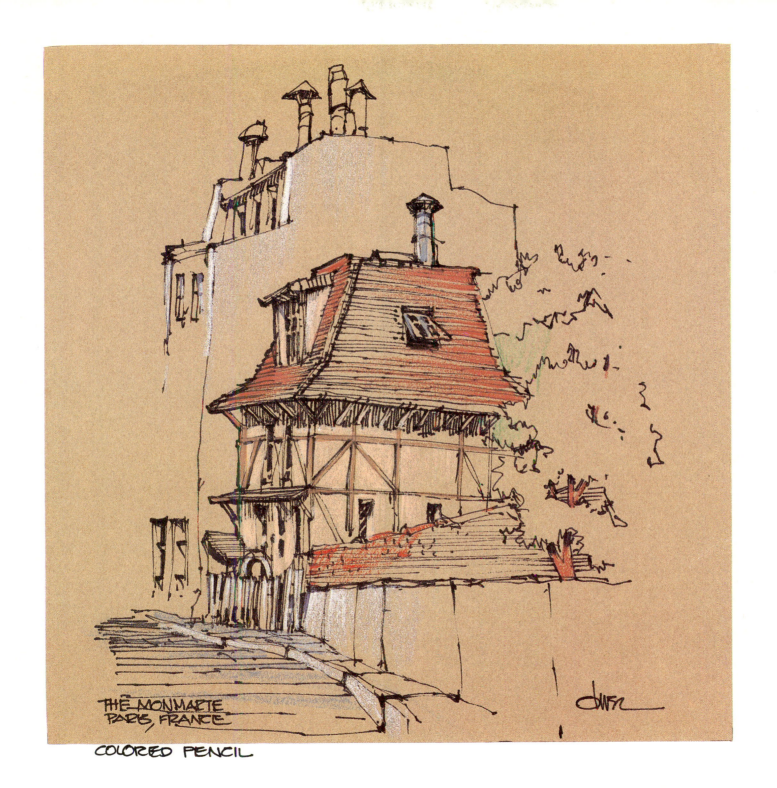

THE MONMARTE
PARIS, FRANCE

COLORED PENCIL

143

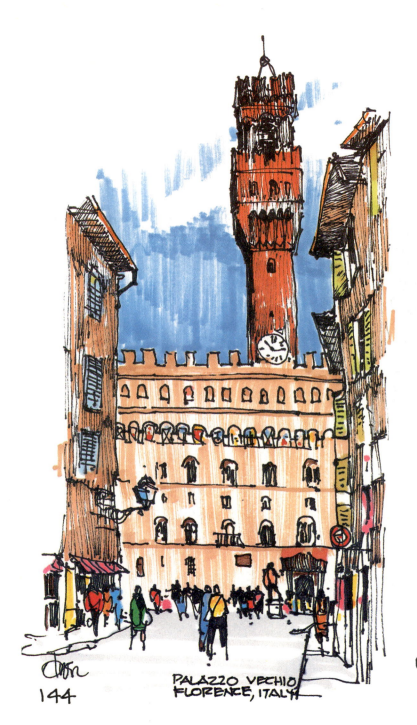

144

PALAZZO VECHIO
FLORENCE, ITALY

MARKER

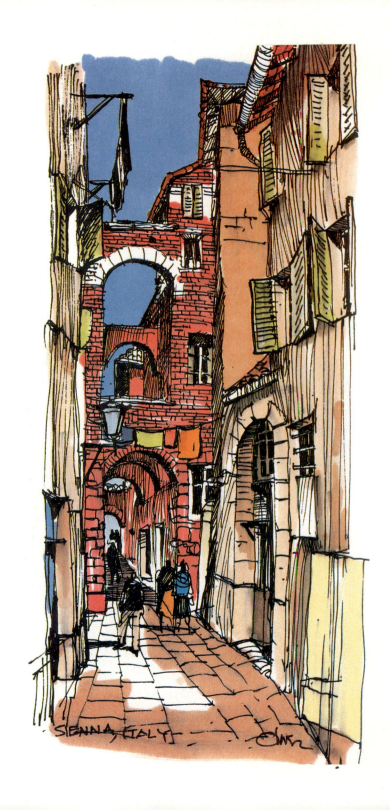

SIENNA, ITALY

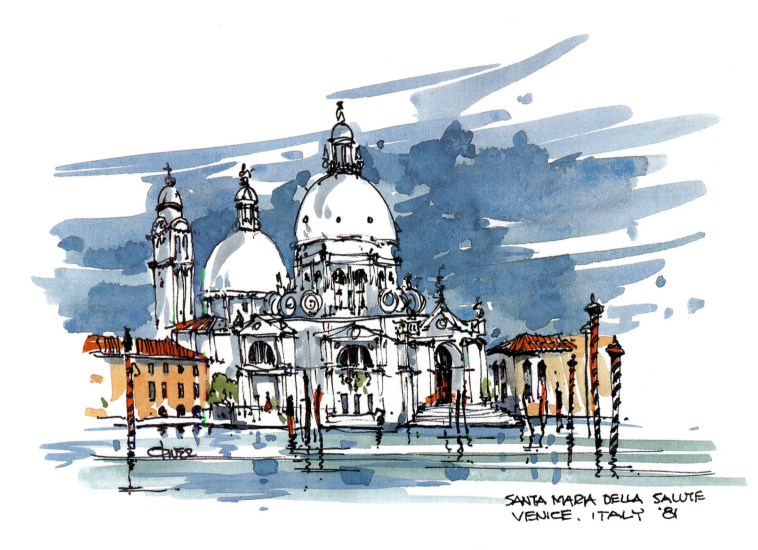

SANTA MARIA DELLA SALUTE
VENICE. ITALY '81

WATERCOLOR.

145

BIBLIOGRAPHY

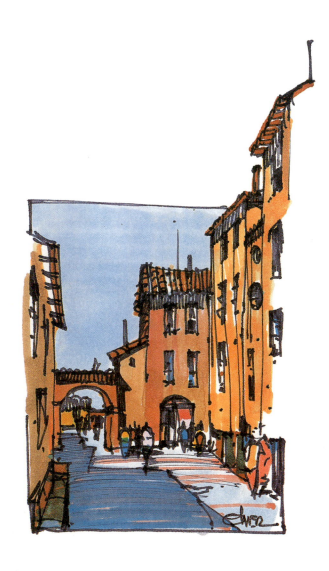

BORGMAN, HARRY
LANDSCAPE PAINTING WITH MARKERS
WATSON GUPTILL 1977

BON-HUI UY
ARCHITECTURAL DRAWINGS AND LEISURE
SKETCHES
BON-HUI UY 1978

DOYLE, MICHAEL
COLOR DRAWING
VAN NOSTRAND REINHOLD COMPANY

GURNEY, JAMES AND KINKADE, THOMAS
THE ARTIST'S GUIDE TO SKETCHING
WATSON-GUPTILL PUBLICATIONS 1982

HOGARTH, PAUL
CREATIVE INK DRAWING
WATSON GUPTILL PUBLICATIONS 1968

HOGARTH, PAUL
CREATIVE PENCIL DRAWING
WATSON GUPTILL PUBLICATIONS 1964

HOGARTH, PAUL
DRAWING ARCHITECTURE
WATSON GUPTILL PUBLICATIONS 1979

146

MAC DONALD, NORMAN
ARTIST ON THE SPOT
WATSON GUPTILL PUBLICATIONS 1969

OLIVER, ROBERT S.
THE SKETCH
VAN NOSTRAND REINHOLD COMPANY 1979

SMITH, STAN
DRAWING AND SKETCHING
EBURY PRESS, LONDON 1982

TROISE, EMILE AND PORT, OTIS
PAINTING WITH MARKERS
WATSON GUPTILL PUBLICATIONS 1972

WANG, THOMAS C.
SKETCHING WITH MARKERS
VAN NOSTRAND REINHOLD COMPANY 1981

WATSON, ERNEST
THE ART OF PENCIL DRAWING
WATSON GUPTILL PUBLICATIONS 1975

WATSON, ERNEST W. AND WATSON, ALDREN
THE WATSON DRAWING BOOK
VAN NOSTRAND REINHOLD COMPANY 1980

WATSON, ERNEST W.
SKETCH DIARY
VAN NOSTRAND REINHOLD COMPANY 1981

WELLING, RICHARD
DRAWING WITH MARKERS
WATSON GUPTILL PUBLICATIONS 1974

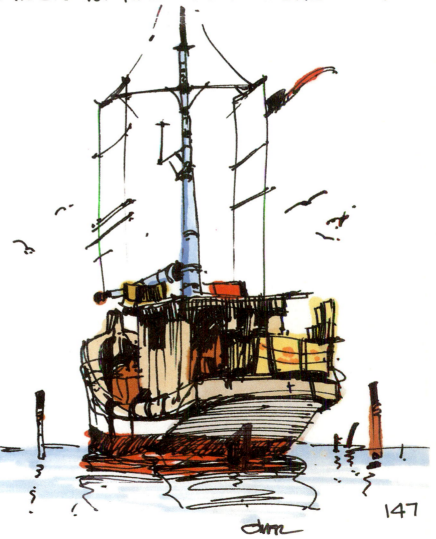

INDEX

ARCHITECTURAL INTERIOR 117

BACKGROUND 34
BALL-POINT PEN 13
BICYCLE 119
BINOCULAR 9
BLACK 28
BOATS 120,121
BRUSH 14
BRUSH TIP PEN 14

CALLIGRAPHIC PEN 12
CAMERA 9
CARBON PENCIL 14
CARRYING CASE 9
CENTER OF INTEREST 36
CHISEL POINT FELT PEN 12
COLORED PENCILS 14
COMPOSITION 33-37
CONTRAST 36

DEPTH 22,23
DETAIL 28
DRAFTING PEN 14

EQUIPMENT 7-14
EVOLUTION OF THE SKETCH 27-30
EYE POINT 40-43

FACES 122
FARM EQUIPMENT 97
FELT TIP PENS 11,12
FIBER TIP PEN 12
FIGURES, HUMAN 122-125
FOREGROUND 34
FOUNTAIN PEN 13

GRAPHITE PENCIL 14
GROUND LINE 40-43

HORIZON LINE 40-43

INK, SOLUBLE 54,59
INK, WATERPROOF 58

LANDSCAPE 130-133
LANDSCAPE CONSTRUCTION 37
LIGHT 24,25
LINKAGE 53,79
LINE 28

MARKERS 8, 11, 72-87
MARKER COLOR PALLETTE 74
MATERIALS AND EQUIPMENT 6-14
MECHANICAL PENCIL 14
MIDDLEGROUND 34
MIXED MEDIA 112-115
MOTOR BIKES 121

OPAQUE WATERCOLOR 64-70

PAPER, TINTED 65-70, 93, 95
PENCIL, COLORED 8, 14, 90-105
PENCIL, SOLUBLE 106-111
PENS 7, 11-14
PERSPECTIVE 39-43

QUILL PEN 13

RADIO 9

SANDPAPER PAD 7, 10
SHARPNEI
SHADES AND SHADOWS 21, 26
SKETCH BOOK 9
SKETCH CONSTRUCTION 27-31
SKETCH PEN 13
SKETCHING POINTERS 16
SPEEDBALL PEN 13
STROKES 20, 21

TECHNICAL PEN 14
THUMBNAIL SKETCH 124, 126, 127
TINTED PAPER 65-70, 93, 95
TONES AND TEXTURES 19-26, 30
TREES 128, 129, 131

VALUES 21, 23, 24-26, 29, 30
VANISHING POINT 40-43

WATERCOLOR, TRANSPARENT 45-63
WATERCOLOR, OPAQUE 64-70
WATERCOLOR KIT 8, 10
WATERCOLOR PALLETTE 46
WATER SOLUBLE PENCIL 14